COPYRIGHT
notice

Merci beaucoup,

Shannon Pratuch

This French Life

FREE ACCESS TO THE DIGITAL VERSION OF THIS MAGAZINE WITH ALL LINKS & VIDEOS:

Table of Contents

Table of Contents

Happy HOLIDAYS

Bonjour, darlings. And bienvenue to another edition of The Paris Quarterly! I am so glad you are here, and merci beaucoup for your support. Now that the magazine is available in print globally, your encouragement and backing means the world - literally! With your help, I can publish my work, sharing French artisans, small businesses, makers, history, and stories with Francophiles worldwide.

When I held the first printed prototype, my heart soared. I remember the days of obsessively collecting Martha Stewart magazines. Each issue was so beautiful, and while I couldn't participate in everything they wrote about, the magazine filled a void for the beautiful life I wanted to create for myself.

I hope the Paris Quarterly can be something similar for you - perhaps filling a void when you are away. And helping guide you through the city when you're here.

Bisous and Bonne Année,
Shannon Pratuch

2022
Christmas

A special edition holiday guide to Paris, France. What to do, where to go, and how to eat, drink, and be merry.

BY THIS FRENCH LIFE 2022

HOLIDAY TRADITIONS

N.6

2022

IN FRANCE

Moving to a new country allows you a whole new perspective on the holidays.

Culture and heritage are a vital part of daily French life. And while some of my American traditions are still relevant in France, others are very different.

The Christmas tree (sapin noël), Santa Claus (Père Noël), New Years celebrations, string lights, and even mistletoe (gui) were all familiar traditions when I arrived. But what was new or unexpected?

In this section, I share popular French Christmas traditions that you might be interested in trying or adopting in your home. Or while you are here in France during the holidays!

"

Childhood is believing that with the Christmas tree and three snowflakes the whole earth is changed.

André Laurendeau

Did you know? While the nativity scene is popular both at churches throughout France and in the family home, did you know that in the years following the French Revolution, crèches were sometimes banned? After the revolution, it was forbidden to represent religious scenes in public, which encouraged families to create nativity scenes at home, usually next to the Christmas tree.

practice your gratitude

Stay grateful & humble

HOLIDAY CELEBRATIONS THROUGHOUT FRANCE

Some customs are unique to the various regions around this spectacular country. Here are a few to learn about or include in your family festivities this year.

PROVENCE

In Provence, small colored clay figurines called santons ("little saints" in Provençal) recreate a nativity scene in the private space of homes.

Made in Provence with the region's red earth, the tradition of santons is still very present in Provence and beyond.

I found a massive stand of them at the Colmar market in Alsace. All village personalities are represented - from the miller to the donkey- gathered around the Holy Family.

Another custom particular to Provence is the feast of 13 desserts, symbolizing the number of guests at the Last Supper (the last meal of Jesus with his twelve disciples). The thirteen desserts are enjoyed after mass. The dessert tray remains on the table for the next three days, until December 27.

THE FEAST OF 13 DESSERTS

Usually displayed on a large decorated dish, the four wise men are represented as the dried figs (Franciscans), almonds (Carmelite), raisins (Dominicans), and walnuts (Augustins). Medjool dates symbolize Christ from the East, while the nougats (black and white) can represent the white and black penitent. It is also said that the soft, white nougat represents purity and goodness, and the harder and brittle black nougat is the representation of forces of evil. Your dentist might agree!

TANTE ARIE

In the Montbéliard region (also home to one of the more beautiful Christmas marchés in France), is an alternative to Santa Claus: Aunt Arie.

"Tante Arie" is, according to legend, a reincarnation of the benefactress and late Countess Henriette de Montbéliard (1387-1444).

A local legend claims that she is a good fairy of the countryside Montbéliard, dressed as a peasant woman, with her donkey Marion loaded with Christmas gifts for the children.

> In Normandy, it is customary on Christmas Eve to burn a "chuquet" log in the fireplace. Called tréfeu or tréfouet, from the Latin tres foci, "three fires," the log burns for three days.

NORMANDY & CHAMPAGNE, FRANCE

This piece of hardwood, sometimes a fruit tree cut down from the forest, is generally placed in the fireplace by the household's father, along with the embers of last year, while the children pray for presents.

On Christmas Eve, before going to midnight mass, it is customary in Champagne-Ardenne to enjoy waffles as a family. The children quarrel over the "little Jesus," the last incomplete waffle of the batch.

LORRAINE

In Lorraine, the patron saint of this region, Saint-Nicolas, has been celebrated for more than 1000 years. The people of Lorraine take this tradition very seriously! Saint Nicolas is the protector of children and the Lorraine, sharing sweets with well-behaved children on the night of December 5 to 6.

Gingerbread is legendary here. The scent of cinnamon, star anise, honey, and orange fills Lorraine's shops, restaurants, and houses; the gourmet scents of the famous gingerbread announce the return of Saint Nicolas! Maison Lefèvre-Lemoine is known for its gingerbread dating back to 1840, with an excellent specialty cookie of Saint Nicolas and donkeys in golden paste or covered with royal icing and painted by hand.

TOP TRADITIONAL HOLIDAY FRENCH FOODS

These dishes and delectable treats are commonly found on the holiday table throughout France.

TURKEY

While roasted turkey is a popular dish on the American Thanksgiving table, the bird makes its annual debut at Christmas, accompanied by chestnuts.

On "Reveillon" evening, the meal enjoyed on Christmas Eve, turkey is often served with oysters, smoked salmon, escargot, and foie gras.

BUCHE NOEL

And we can't forget dessert! The "Buche de Noel" or "Christmas log" first appeared in France around 1870. This incredibly delicious layered chocolate cake is covered with a butter-cream frosting and rolled into the shape of wooden logs, a likeness to the same logs in the fireplace to heat their home.

SHOPPING

N.6

2022

& GIFT GIVING

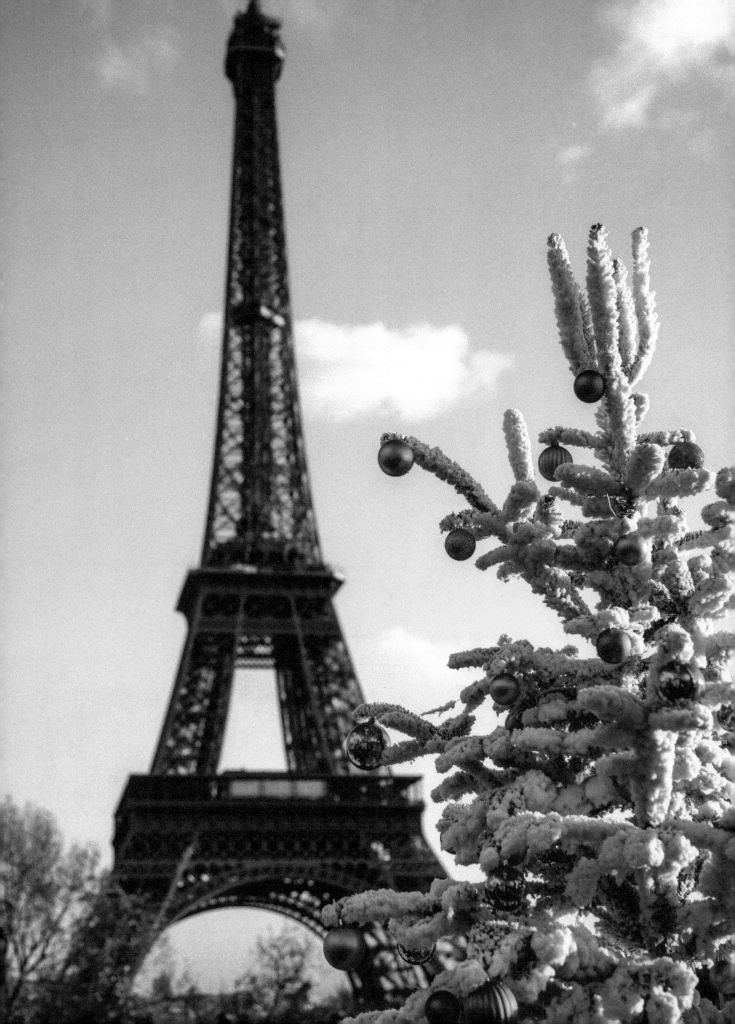

Paris Christmas

POP UP BOUTIQUES

When writing this edition, I found the following concept stores and holiday pop-ups for you to visit. Be sure to double-check the dates and times. As more are released throughout the season, I will share those details and locations in my Instagram story. The benefit of these concept stores is that you can shop locally and at lower prices than the marché noel.

Treat Yourself

Astier de Villatte

Created in 1996, Astier de Villatte is an artisanal ceramics workshop in Paris, the only one of its kind, which modernizes the tradition of 18th-century Parisian art of stamping. During the holidays, there is an ephemeral Christmas boutique on the second floor of its store, full of holiday decor and treats to take home.

Astier de Villatte has a typographic printing press in the suburbs of Paris, the last in France (and one of the last in the world) to print lead books.

Be sure to also check out the perfume creation workshop where you'll discover colognes, skincare, incense, and a whole collection of scented candles.

173 rue Saint Honoré, 75001 Paris
+ 33 1 42 60 74 13
Monday to Saturday, 11 a.m. to 7 p.m.

Dada Market

On December 3 and 4, 2022, visit the Galerie Joseph at 116 rue de Turenne, in the Haut Marais in Paris, for the X-Mas Edition of Dada Market (free entry)!

An event which aims to be a springboard for young committed brands by highlighting their products, their values and their know-how. The ideal place to make your Christmas gifts in a thoughtful and respectful way for our planet while supporting young artisans.

Dada Market is the new showcase for committed brands. Like the Dada or Dadaism movement (an artistic movement born in 1906 from a desire to break away), Dada Market invites us to reflect on our consumption.

https://www.dadamarket.fr/

Carrousel des Métiers
d'art et de création

This exhibition-sale is dedicated to arts and creation crafts at the Carreau du Temple in the Marais. 130 exhibitors in the fields of fashion, decoration and design will present creations placed under the sign of artisanal excellence.

This is a unique opportunity to buy, just before the holidays, unique pieces made in the workshop, ethical, sustainable and creative gifts: lighting, tableware, design furniture, jewelry, shoes, ceramics, and more.

Free entry, on registration.
December 1 - 4
DETAILS & FREE REGISTRATION HERE.

Ouvert de Noël

A combination of exhibitions, musical discoveries, stands of emerging designers and a café-bar to accompany customers in their wanderings. The Christmas market that will take place between the last days of November and the first days of December. Open Nov 28 to December 4. 2 Rue Saint-Honoré, 75001 Paris, France

La Fabrique du Père Noël

1200m2 space in the heart of the Marais, on 5 rue Saint Merri, Paris IV, you'll find nearly 200 emerging brands. It's the ideal place to unearth the most beautiful and trendy gifts to offer this year. Red carpet, rhinestones and glitter: Santa's Factory 2022 will be under the sign of glamour on the theme "Red Christmas Party." Not to be missed: between 70 and 80 new brands alternate each week so you'll never get bored. Opening Dec 1

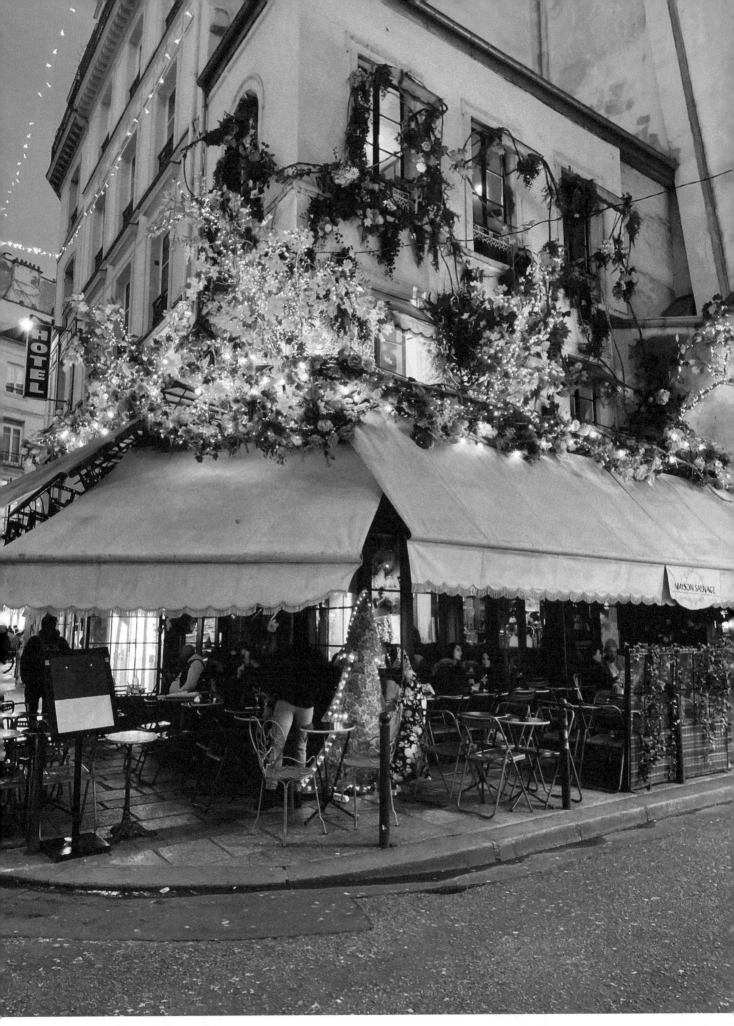

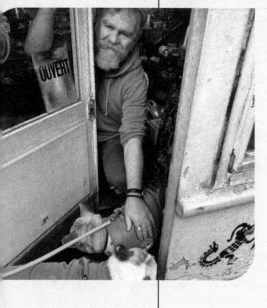

Antiques & Collectibles

VERRE GLASS

I thought I had found Santa when I came across Claudius Breig as he was hanging vintage glass ornaments in the window. Claudius specializes in vintage glass, and his shop is a mix of anything "verre" imaginable - candy dishes that your grandmother used to set out on a doily, vases, bowls, lights, and so much more. Mr. Breig's shop is open "in the afternoon" from Tuesday to Saturday and only accepts cash. You won't find Verreglass online - this is the epitome of a treasure in Paris.

VERREGLASS

32 RUE DE CHARONNE
75011 PARIS

PHONE 01.48.05.78.43

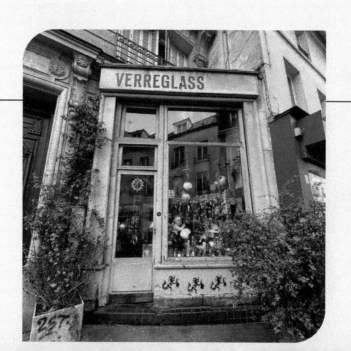

Department Stores

FOR FOOD & GIFT GIVING

01 BON MARCHÉ

This dog-friendly department store goes all out on the Christmas decor, stunning windows, pop-up shops, a Christmas decor section, and so much more.

02 GALERIES LAFAYETTE

Aside from the famous two-story Christmas tree and light show, GL also offers incredible window decorations and on-site activities not to be missed.

03 BHV

My love for this Marais department store knows no bounds. Dog-friendly, less expensive than the above listed, and easy to navigate, you'll find me and the girls here often on a rainy Sunday.

04 GRANDE EPICERIE

Part of the Bon Marché and located directly across the street, this multi-story food store showcases the best products France has to offer.

05 LAFAYETTE FOOD COURT

Similar to the Grand Epicerie, the GL food court has a wide variety of eateries and groceries. You'll also find Christmas decor on the upper floors.

06 EATALY

Part of the BHV complex, Eataly is an Italian grocery complex. From the huge wine selection in the basement, to the on-site eateries, to the fantastic array of Italian food imports, it's not to be missed!

Get it Delivered!

If you have a bigger order to place and want your groceries delivered, I suggest Mon Marché or Monoprix.

"City sidewalks
Busy sidewalks
Dressed in holiday
style
In the air
There's a feeling
Of Christmas..."

Silver Bells

CHRISTMAS IN PARIS

N.6

2022

RUE SAINT HONORÉ

8ᵉ Arrᵗ

WHERE TO GO

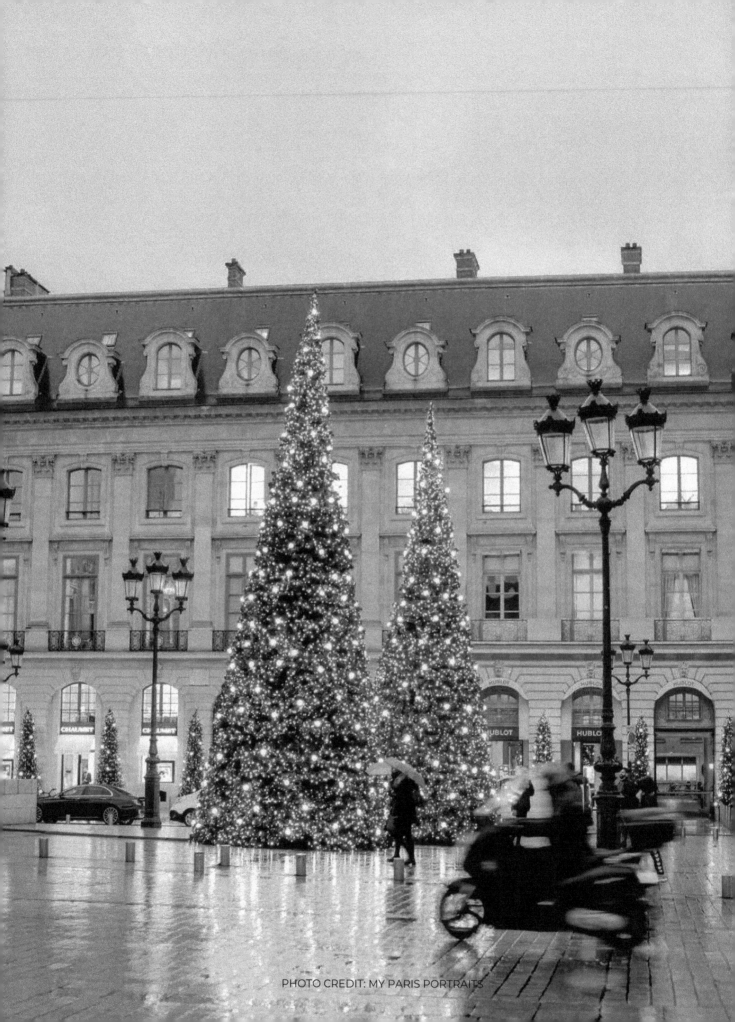

Bon Marché CHRISTMAS ITINERARY

1 Spa

Start your day with a bit of pampering! Free Persephone is a stunning nail bar with the BEST pedicure packages. They also have a tea salon that offers yummy treats and holiday gift sets to go.

2 Lunch

La Table is a stunning restaurant in the middle of the Bon Marché. It's the perfect spot to have lunch before exploring the department store.

3 Shop

Explore the Bon Marché inside & out! The festive windows are not to be missed. Christmas decor is usually tucked next to the library section. I also love the pop up booths on the ground floor.

4 Be Grateful

Across the street and hidden up an alleyway is Chapel of Our Lady of the Miraculous Medal, a stunning art nouveau church. VIDEO TOUR LINK

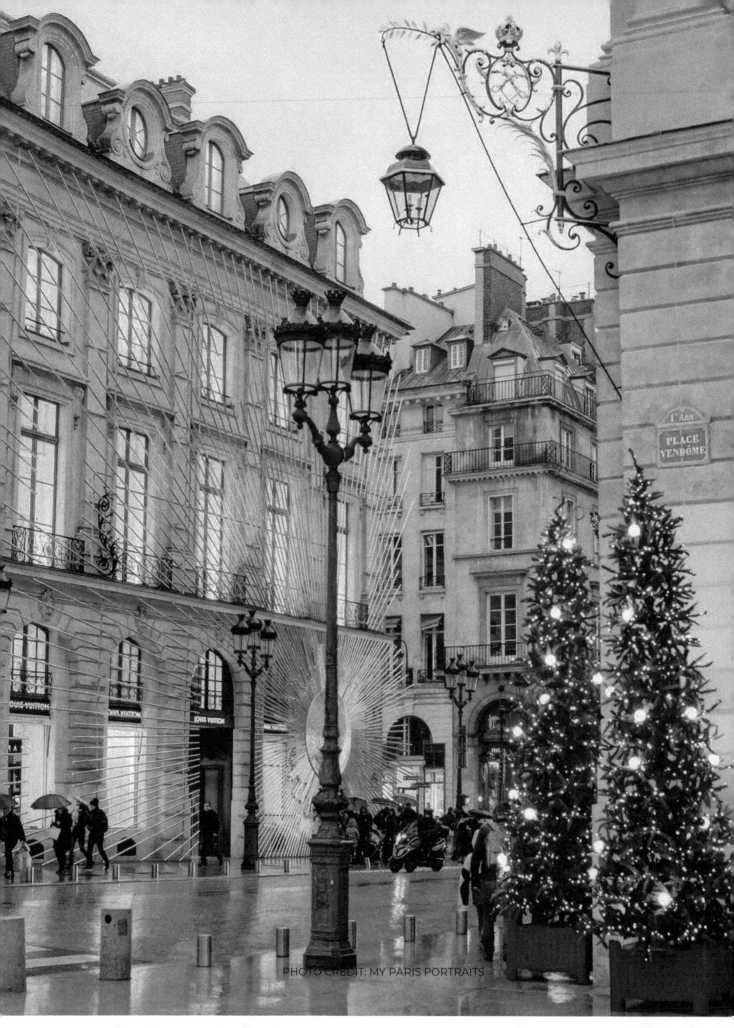

Galerie Lafayette CHRISTMAS ITINERARY

1 *Opera*

Start this day with a tour of the Palais Garnier. Be whisked into a magical world of stunning architecture, culture, art, and beauty. You can book your visit here.

2 *Lunch*

Extend your Opera experience in a historic and beautiful atmosphere in this opulent 1800's restaurant, Café de la Paix. Reservations are crucial.

3 *Shop*

Practically across the street is the department store Galeries Lafayette. Visit the window displays before heading inside to see the magnificent Christmas tree.

4 *Cocktail*

Fancy a drink? Head over to Harry's New York Bar, an institution in Paris since 1911. Over 400 cocktails, piano bar, cuban-style cigars, and a vast whisky collection.

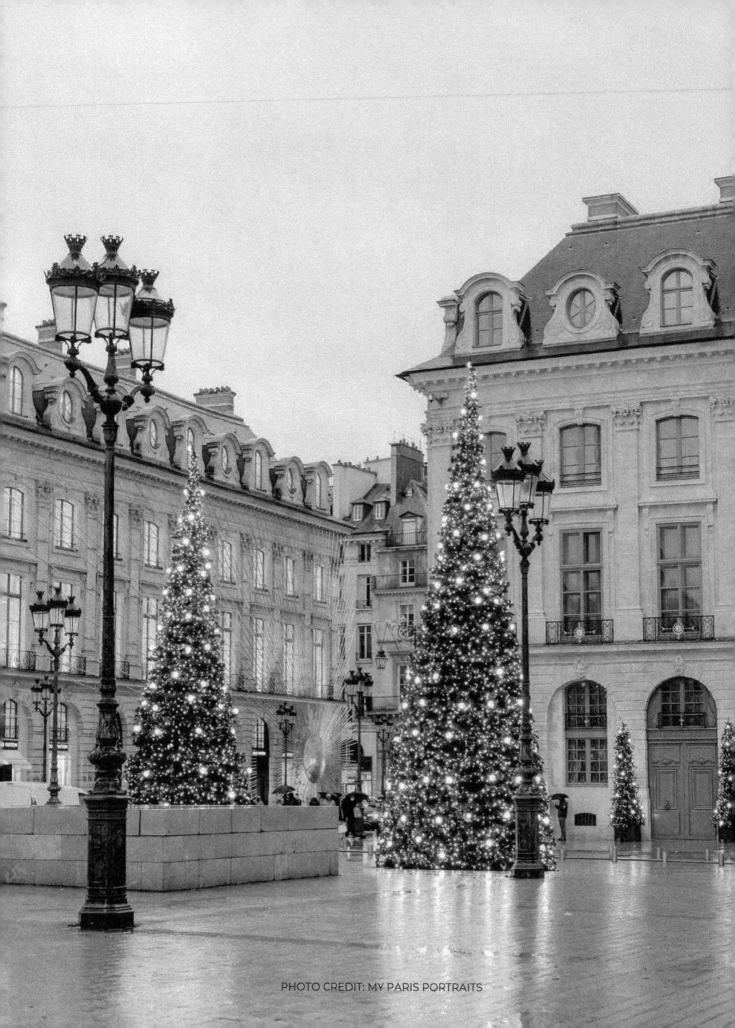

"*Christmas is the day that holds all time together.*"

Alexander Smith

Four days before

Take in the last of the Christmas marchés! Many of them close permanently on Christmas Eve. This is also a great time to buy specialty food items.

Three days before

Shop for white goods, basic ingredients, and grocery store supplies at your bigger markets like Monoprix. They will be closed for the holidays.

> ❞
>
> *Some Christmas tree ornaments do more than glitter and glow, they represent a gift of love given a long time ago.*
>
> *Tom Baker*

Eve of Christmas

Consider attending a special concert or midnight mass. Most of the incredible churches in Paris offer special events on Christmas eve. Some concerts require tickets in advance so check around your neighborhood.

Day of Christmas

After your traditional actvities, join others for who enjoy the art of the "flaneur," one who wanders the streets of Paris - just because! It's especially romantic at dusk, when all of the Christmas lights are on.

Join me Online!

Save the Date for these livestreams available on Instagram and YouTube.

Abbesses French Marché

The Montmartre market is the only all-French outdoor marché Noel in Paris. I will announce this based on weather conditions.

WEEK OF DEC 5

Saint-Germain-des-Pres Marché

This will be a longer tour from the St Germain market and we will end at Hotel de Ville. I'll announce the date & time based on weather.

WEEK OF DEC 12

Notre Dame Marché

One of my favorite markets in Paris, this marché has an old-world feel in the shadows of Notre Dame.

DECEMBER 16TH

MAP

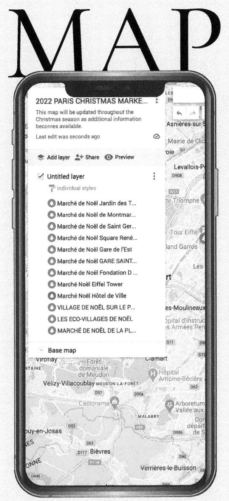

Paris Christmas Markets

AND ILLUMINATIONS

Find the nearest Christmas lights and marché noel closest to you!

I have mapped out all of the holiday markets for the 2022 season and will continue to add as they come available.

CLICK HERE

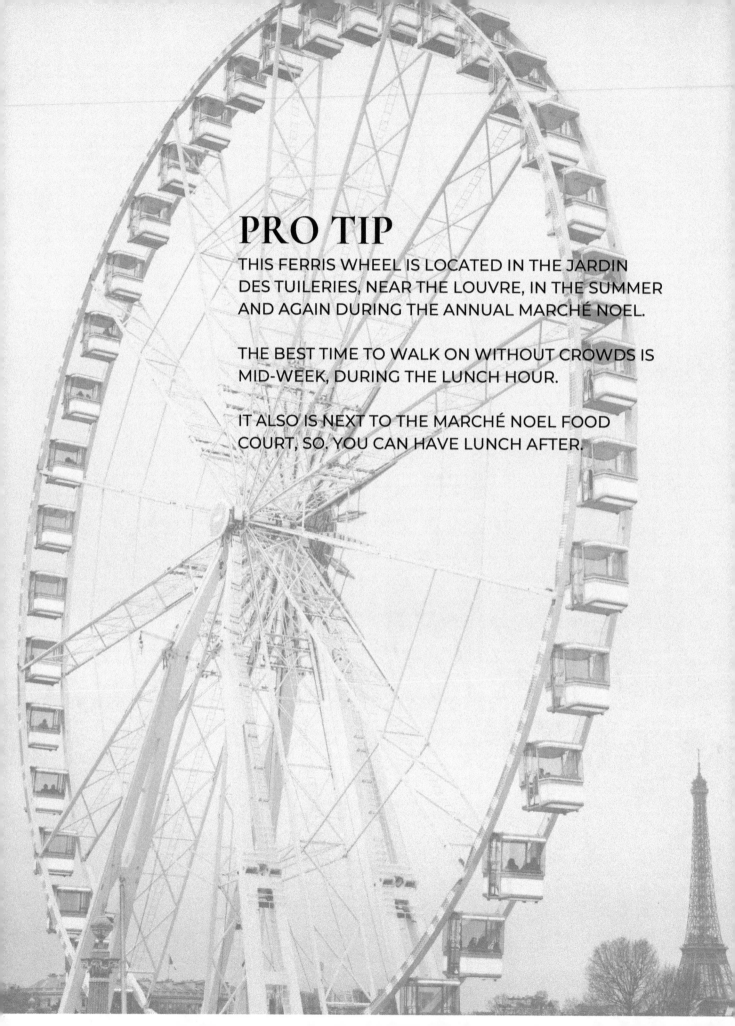

PRO TIP

THIS FERRIS WHEEL IS LOCATED IN THE JARDIN DES TUILERIES, NEAR THE LOUVRE, IN THE SUMMER AND AGAIN DURING THE ANNUAL MARCHÉ NOEL.

THE BEST TIME TO WALK ON WITHOUT CROWDS IS MID-WEEK, DURING THE LUNCH HOUR.

IT ALSO IS NEXT TO THE MARCHÉ NOEL FOOD COURT, SO, YOU CAN HAVE LUNCH AFTER.

Book These Tours

Our partners are offering exceptional experiences this Christmas season.

April in Paris

Get into the holiday spirit with this magical evening tour around the City of Light. Visit window displays & Christmas markets, sip on vin chaud & experience Paris as a winter wonderland on this special 4-hour tour.

BOOK NOW!

My Paris Portraits

There's not much better than a gift that lasts for decades. My Paris Portraits photo shoot EXCLUSIVE PROMO CODE! Use the code FESTIVE10 for 10% off of any photoshoots (valid for November & December 2022).

BOOK NOW!

Molly Wilkinson

Impress your guests with delicious treats! Molly's December baking courses include Wreath Macaron class with Maple Clove Buttercream, Holiday Cookie Party, Buche de Noel & Croqeumbouche.

BOOK NOW!

VIRTUAL TOUR

N.6

2022

CHRISTMAS AT A CHATEAU

MERRY
&
BRIGHT

VAUX-LE-VICOMTE

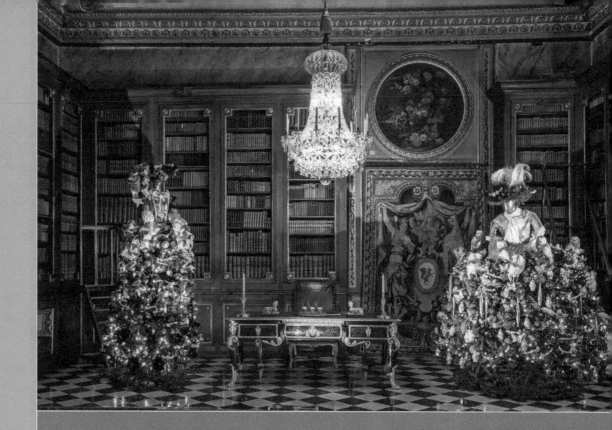

celebrate

On the occasion of the 400th anniversary of his birth, Molière returns to the Château de Vaux-le-Vicomte.

Starting November 19, the playwright will be at the heart of a completely renewed program that will immerse visitors in his world. To welcome this illustrious artist of the Grand Siècle, Vaux-le-Vicomte will be transformed into a Palace of the Arts.

The courtyards, the outbuildings, the castle and the French garden will welcome visitors in an enchanted world that will take them on a magical journey, with activities for young and old: workshops, shows, treasure hunts, gourmet breaks by the fire, horse-drawn carriage rides, and more.

EXPERIENCE
FRENCH CULTURE

"The Vaux-le-Vicomte en fête event has been redesigned to offer a new experience to our visitors, sharing a multitude of activities adapted to all audiences."

The Grand Entrance

As soon as guests arrive on the estate, visitors will pass through the "Artists' Entrance". This is precisely where Molière will take up residence. Visitors will receive a red cape, in a subdued atmosphere to the sound of Lully's arias, and will then pass through different spaces, in which four giant golden frames will transport them to the world of Molière from the beginning of the visit.

There will be thousands of lights throughout the property.

Unforgettable!

Good to Know!

Les Fâcheux was Molière's first comedy-ballet, commissioned by Nicolas Fouquet for the party he gave for Louis XIV's entertainment at the Château de Vaux-le-Vicomte in August 1661. The comedy was conceived, learned, and performed in fifteen days.

Thanks to the staging of costumes, sets and automatons, visitors will witness the creation of a play, up to a tableau vivant animated by two actors who will be busy rehearsing the famous play Les Fâcheux, created by Molière in 1661 at Vaux-le-Vicomte. You'll have to get caught up in the game and immerse yourself in the atmosphere of this moment of emulation.

After this immersion, visitors will be invited to pass through the Courtyard of the crews, decorated with 60 golden and silver birches. Then the main courtyard with its avenue of 40 illuminated fir trees adorned with golden masks will offer a gentle stroll in the open air in a warm atmosphere and will allow visitors to admire the magnificent exterior decorations while listening to baroque music, all the way to the entrance of the castle for the beginning of the festivities!

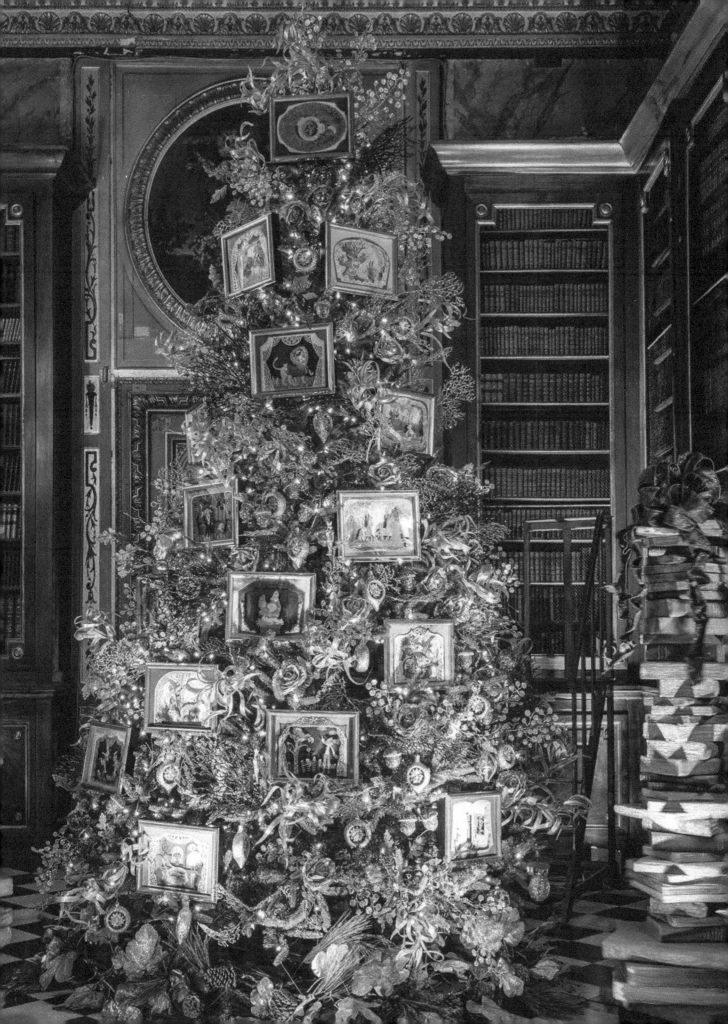

DID YOU KNOW?

More than a play, the Bourgeois Gentilhomme is a comedy-ballet for which Molière and Jean-Baptiste Lully collaborated. Created in 1670 by Molière's troupe before the court of Louis XIV.

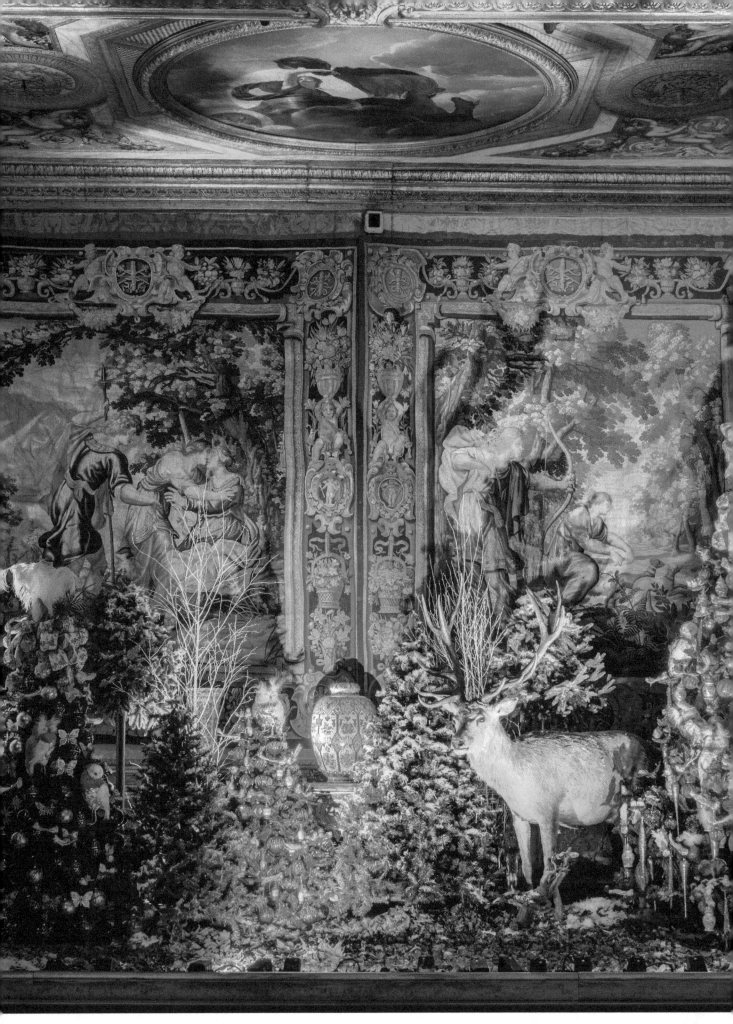

Visitors will be immersed in the festivities of the 17th century during a 360° projected images on the 1000 m2 walls and dome of the Grand Salon. They will witness a spectacular reinterpretation of the Ceremony of the Turks from the Bourgeois Gentilhomme, set to music by Lully. For the occasion, the Grand Salon will be transformed into a theater for the duration of the projection, with sets of turqueries.

The terms will reinterpret the lessons of Monsieur Jourdain: songs, fencing and spelling while the dome vault will be transformed into theater boxes. On the walls of the Grand Salon, a ballet will be played on baroque tunes mixing farandoles of XVIIth century characters, music and dance! Mirror games will complete the show. The 4-minute projection will be repeated in a loop so that all visitors can enjoy it during their visit of the castle.

Stunning video projections.

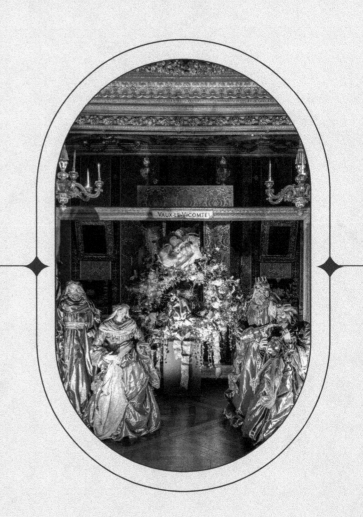

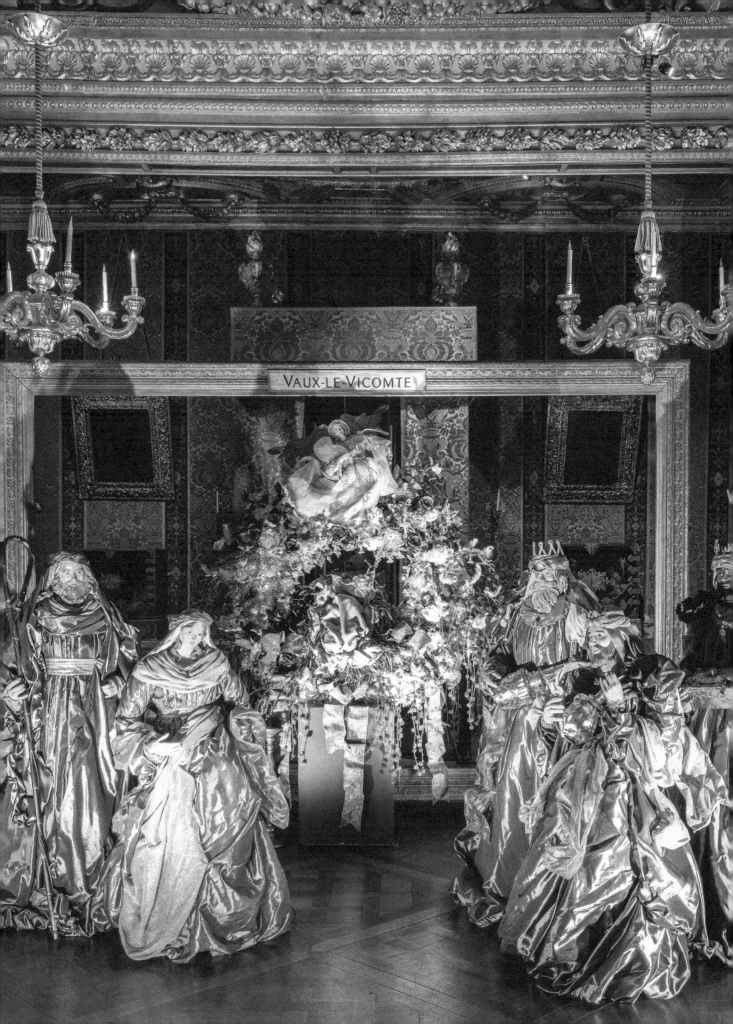

VAUX-LE-VICOMTE

Inside the Château

Inside the castle, the Vaux-le-Vicomte en fête experience will take visitors into the famous inspirations of Molière, honored in the ceremonial rooms. As a starting point, the vestibule dressed with a giant silver garland, then the Grande Chambre Carrée. Our guests will be welcomed and greeted by Molière and Nicolas Fouquet, thanks to animated automatons. Once in the Muses' Room, they will have the chance to attend the famous play "L'École des Maris", with large characters in fir robes, staged in red and gold tones.

Beauvron-en-Auge

I have been to this village twice in a year, I love it that much. This is the most touristic village of the three, with tour buses crowding the public parking spot in high season. I've visited off-season both times and found the village to be quaint, quiet, and full of antique stores to discover. Beauvron-en-Auge is also on the famous Normandy cider route.

Both visits, I have booked a lunch at Le Pavé d'Auge restaurant (online reservations available). *I consider both experiences one of the top culinary meals I have had in all of France.*

The event in numbers!

13,000

DECORATIVE
OBJECTS

4,000

METERS OF
STRING LIGHTS

3.5

METER
LIGHTED
ANGEL

80,000

MARSHMALLOWS
DISTRIBUTED TO
GUESTS

For young and old gourmets alike, you will undoubtedly want to taste the piece made by Jean Luc Decluzeau, famous chocolate sculptor: a giant bust, 70 cm high representing Molière, to devour... with your eyes!

In the Salon d'Hercule, an automaton of Harlequins, staged in a decor of 1001 colors in the middle of fir trees in which will be suspended sugar masks of the house Canasuc.

Delicious!

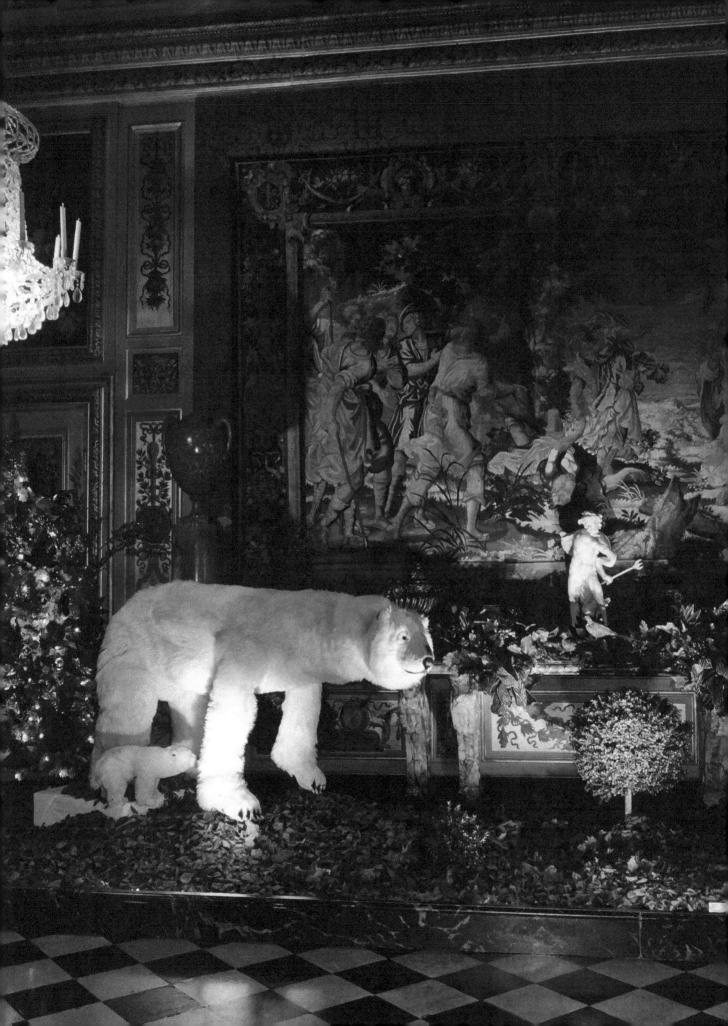

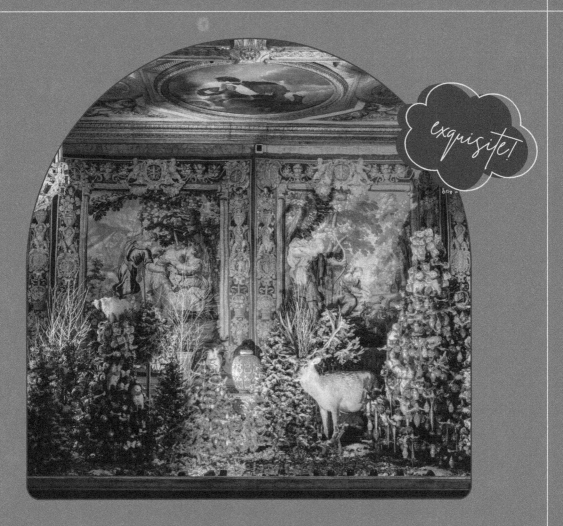

exquisite!

In the library, it is the effervescence around the school of the women. In a golden setting, an army of little automatons are busy making the famous play. The visit continues in the King's Chamber, with this time a tribute to Lully, Molière's faithful friend and partner. In a décor of toile de Jouy, our visitors will discover the musical instruments dear to the artist.

Then, let's go to the King's Cabinet to marvel at the crib filled with little squirrels, Fouquet's emblem!

In the Buffet Room, visitors will discover the art of French-style entertaining, with a large 5-meter long table, magnificently set for a festive meal. A sublime setting with porcelain, floral art and decorations. A true magnificence of the French savoir vivre and French know-how.

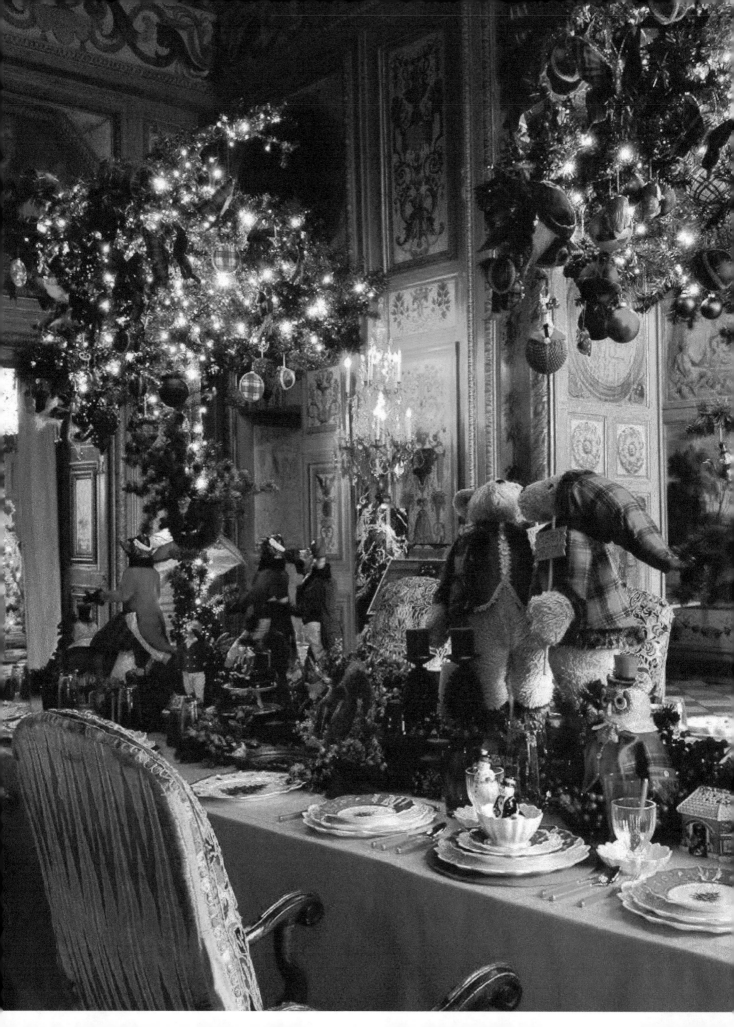

Vaux-le-Vicomte
IN THE CHATEAU GARDENS

Fun and Poetic Tours

In the gardens, visitors will be invited to take part in the Molière Trail created especially for the occasion. They will be given a booklet that will allow them to complete a fun and family-friendly tour, with a program of participatory works, games, calligraphy, a workshop on the art of fly tying and many other surprises.

During these challenges, visitors will be plunged into the year 1661, when Molière was busy preparing his comedy-ballet Les Fâcheux commissioned by Nicolas Fouquet.

They will discover the writing and staging of this great classic by Molière. Each participant's booklet will be sealed with a seal and a present will be given to all the children at the end of the play.

Gourmet Moments

Every day, the domain will offer a gourmet break by the fire. Each visitor will be given a marshmallow to roast on one of the braziers on the orangery terrace and to enjoy while listening to the famous tunes of Molière's comedies and ballads.

Carriage Rides & Costumes

An original and relaxing way to discover the French gardens of André Le Nôtre. Horse-drawn carriage rides will be offered on the estate.
(Extra charge: 6 € and 4 € for children under 10 years old).

For a total immersion, Vaux-le-Vicomte will propose costumes for rent for your visit of the castle.

Did you know?

Discover a panoramic view of the entire estate from the lantern overlooking the dome, the highest point of the castle. A breathtaking view at more than 25 m above the ground!
(3 € in addition to the entrance fee)

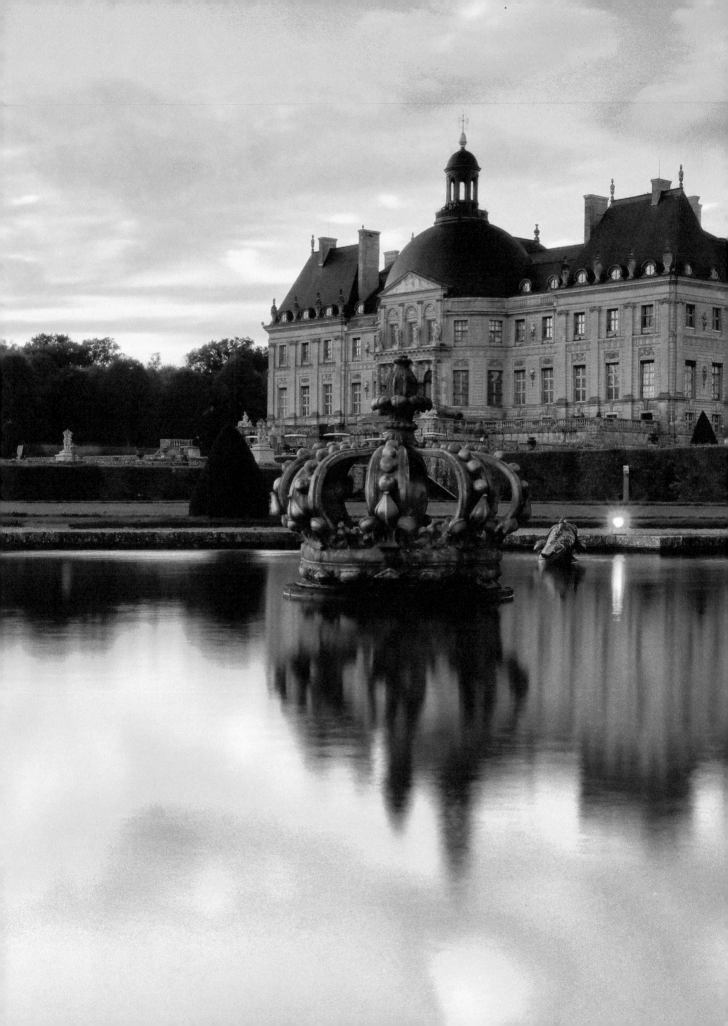

DATES & DETAILS

From November 19 to December 31:
- Open from Wednesday to Sunday from 10am to 5:30pm (last admission)

Christmas vacations from December 17 to December 31:
- Every day from 10 am to 5:30 pm (last access at the counter)
- Except on December 24 and 31: from 10am to 4:45pm (closing at 5:45pm)

Closed on December 25

Ticket price for the castle and garden:
- Adult rate : 21,90 € (for adults)
- Reduced rate : 19,90 €
- Free for children under 6 years old
- Free parking

Purchase Online!

Coming Soon!
VIDEO TOUR

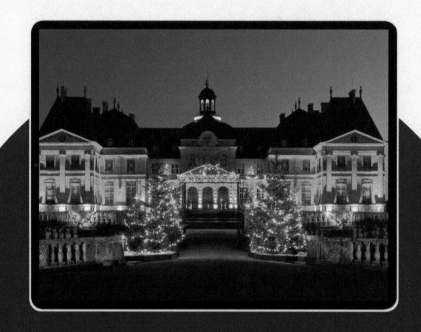

I will be joining a press trip at the end of November and sharing an exclusive, behind-the-scenes tour with my newsletter subscribers.

JOIN NOW

"Christmas doesn't come from a store. Maybe Christmas perhaps means a little bit more."

Dr Seuss

Hiver

This French Life

PUBLISHED: NOVEMBER 2022

ARTS & LITERARY

N.6

2022

GOOD READS

Alfred de Musset

A FRENCH POEM WITH TRANSLATION & HISTORY

Que j'aime le premier frisson d'hiver...

Que j'aime le premier frisson
d'hiver ! le chaume,
Sous le pied du chasseur,
refusant de ployer !
Quand vient la pie aux champs
que le foin vert embaume,
Au fond du vieux château
s'éveille le foyer ;

C'est le temps de la ville. – Oh !
lorsque l'an dernier,
J'y revins, que je vis ce bon
Louvre et son dôme,
Paris et sa fumée, et tout ce beau
royaume
(J'entends encore au vent les
postillons crier),

QUE J'AIME LE PREMIER FRISSON D'HIVER...

Que j'aimais ce temps gris, ces passants, et la Seine
Sous ses mille falots assise en souveraine !
J'allais revoir l'hiver. – Et toi, ma vie, et toi !

Oh ! dans tes longs regards j'allais tremper mon âme
Je saluais tes murs. – Car, qui m'eût dit, madame,
Que votre coeur sitôt avait changé pour moi ?

How I love the first shiver of winter...

How I love the first shiver of winter! the stubble,
Under the hunter's foot, refusing to bend!
When the magpie comes to the fields scented by the green hay,
At the back of the old castle the hearth awakens;

It's city time. - Oh ! when last year,
I came back to it, when I saw this good Louvre and its dome,
Paris and its smoke, and all this beautiful kingdom
(I can still hear the postilions shouting in the wind),

How I loved this gray weather, these passers-by, and the Seine
Beneath its thousand lanterns seated as sovereign!

I was going to see winter again. –
And you, my life, and you!

Oh ! in your long gazes I was going to soak my soul
I greeted your walls. "For who would have told me, Madame,
That your heart had immediately changed for me?

Alfred de Musset

Alfred de Musset was a French poet, playwright and writer of the Romantic period, born on December 11, 1810 in Paris, where he died on May 2, 1857.

In 1829, Musset published his first poetic collection, Tales from Spain and Italy, hailed by Pushkin. He is also the only French poet of his time that the Russian poet really appreciated.

In 1830, at the age of 20, Musset's reputation is centered around his "dandy side" and debauchery. The poet also begins a relationship with George Sand.

Depressed and alcoholic, he writes less and less after the age of 30. Musset was appointed librarian of the Ministry of the Interior on October 19, 1838. Under the Second Empire,

Musset is buried at Pere-Lachaise cemetery, Paris, France.

On the stone are engraved the six octosyllables of his elegy Lucia :

My dear friends, when I die,
Plant a willow in the cemetery.
I love its weeping foliage;
Its pallor is sweet and dear to me,
And its shadow will be light
On the earth where I will sleep.

he became librarian of the Ministry of Public Instruction. Appointed Knight of the Legion of Honor at the same time as Balzac, Musset was elected to the French Academy on Feb 12, 1852. Just a few years later, he dies from alcoholism and tuberculosis on May 12, 1857.

SAINT MARTIN'S GHOST IN THE METRO

AN "UNDERBELLY QUARTERLY"
SPECIAL SECTION BY WALK.PARIS

Finding affordable, safe & sanitary housing is a perennial problem in Paris. But in winter, it becomes a matter of life and death for the city's homeless.

The dwindling population of monks and nuns in Paris' abbeys and convents has given rise to a trend of converting them into short-term housing.

Village Reille in the 14th arrondissement is a good example. But these large compounds with private gardens eventually need to be handed over to their new owners: real estate developers.

Saint Martin's Ghost

Other long-term options have been tried, such as decommissioned 19th-century military forts, but these are usually too far away from the city centre. Some even proposed using the 150km-long network of empty catacombs under Paris because they never freeze (the temperature remains a constant 13°C) but they are just too deep, and have neither light, electricity nor running water.

So what about metro stations? They are ubiquitous, easily accessible, have all of sorts of utilities. But the metro stations are already used by 4 million travellers everyday - *or are they?* Enter some of Paris' largest and most fantasy-inspiring secret locations: "ghost metro stations."

These stations aren't truly haunted, per se, they're just not officially in use.

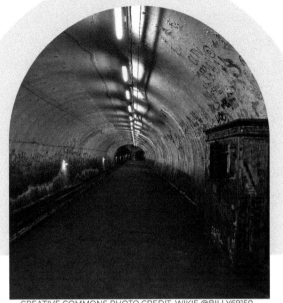

CREATIVE COMMONS PHOTO CREDIT, WIKIE @BILLY69150

They are sometimes still visible today, fleeting visions from metro cars that pass them without stopping. Some of the ghost stations were partially built, but their access staircases were never dug out, such as "Haxo" in the 19th arrondissement. Others were fully finished and used, but were shut down during WWII to reduce operating costs. The largest of these is "Saint-Martin," at the border of the 3rd and 10th arrondissements, on metro lines 8 and 9. After a last attempt at revival in 1941, it proved too

close to nearby stations and, to this day, trains now just pass it and stop at "Strasbourg - Saint-Denis," only 100 meters away.

Unbeknownst to most, Saint-Martin station is actually still in use - just not for transporting Parisians.

The western side of Saint-Martin station was first used for experimental advertising in 1948, with giant ads made of porcelain tiles. Longer-lasting than paper posters, these ads sometimes literally popped out of their frames as thick relief could be added to the 2D-graphics. That concept didn't take off, but the fact that Saint-Martin's platform is still visible from passing trains has led it to be used over the years for art installations or publicity stunts by H&M, Microsoft, Nike, or film producers who even placed props from Ridley Scott's "Prometheus".

The ceramic concept ads can still be visited with metro employees, who even have a room dedicated to the history of the metro, including some old maps of the catacombs!

While the west is devoted to consumerism, Saint-Martin's eastern sectors show its more charitable side, creating an eerie connection across centuries.

Saint-Martin station is named after rue Saint-Martin, which in turn is named after the nearby Priory of Saint-Martin-des-Champs.

Today it is known as the Conservatoire National des Arts & Métiers, which includes a quirky museum dedicated to the history of technology.

It's probably the only church in the world where you can see a plane, a car, and Foucault's pendulum hanging from the vaults.

The Priory itself is named after Saint Martin of Tours, a 4th century Roman soldier who converted to Christianity and is famous for splitting his cape in two to save a homeless man from freezing to death.

Which brings us back to today's homeless population in Paris. In 1988, the platform of Saint-Martin's station on line 8 was walled off from the metro tracks so that its vast expanse could be used as a homeless shelter.

Housing people overnight eventually proved unsustainable, but since 2000, the Salvation Army has run a daytime service point inside the station. Homeless people can get a free breakfast, shower, receive legal & job search advice... as well as a mailbox.

So while nobody sleeps overnight inside Saint-Martin station anymore, people do live there administratively, with a proper postal address at 31 boulevard Saint-Martin. To be fair, Saint Martin was busy being the bishop of Tours, and didn't spend a lot of time in Paris, though legend has it he did kiss & heal a leper when he visited in 385-386 CE. But he would probably be happy to know that centuries later, in secular France, his legacy of helping the poorest lives on, under the streets of Paris.

Comte de Saint-Germain

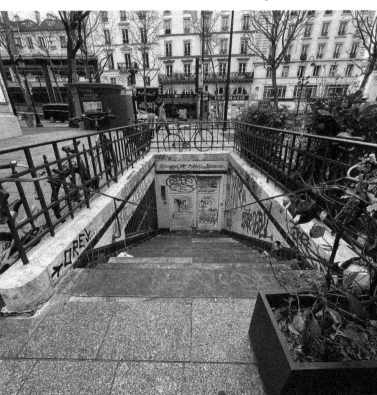

DOWNLOAD THE WALKING TOURS

episode 1

AROUND MONTSOURIS

DATE ◀◀ ▶ ▶▶ 15:20

episode 2

ABOVE THE CATACOMBS

DATE ◀◀ ▶ ▶▶ 15:20

You may have heard of this 14th district park, but the surrounding neighbourhood has an incredible history: nearly 2000 years of ruins, visible from its streets, and locals ranging from the first Black star of Montparnasse (before Josephine Baker!) to a leftist lesbian painter who became a heroine of the Resistance during WWII.

This brand new tour will take you on the footsteps of gentleman thief Arsène Lupin, above the underground locations that were used to film a very special episode of the hit Netflix series.

Learn about the legal and not-so-legal uses of the catacombs over more than five centuries.

LISTEN NOW!

LISTEN NOW!

More about the Count

The Count of St. Germain invites you to unique walks through Paris. Let his voice and your smartphone's GPS guide you to (re)discover the City of Lights, embracing the authenticity and subjectivity of a person who actually experienced the events they're recounting.

MORE INFO

Books
TO READ

In collaboration with the <u>Abbey Bookstore in Paris</u> and owner Brian Spence, we are pleased to share a fantastic selection of books perfect for cozy winter nights.

THE LAST TIME I SAW PARIS

BY ELLIOT PAUL

Originally published in 1942, this is the author's memoir of a time he spent in Paris between the two world wars & his daily life on Rue de la Huchette.

★★★★☆
AMAZON RATING: 4.2

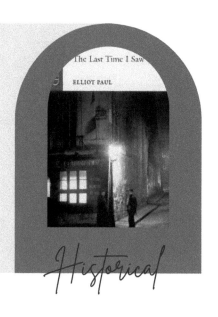

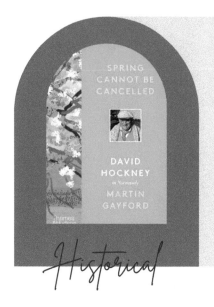

SPRING CANNOT BE CANCELLED

BY MARTIN GAYFORD

David Hockney reflects upon life and art as he experiences COVID lockdown in rural Normandy - includes conversations with the artist and his latest artworks.

★★★★☆
AMAZON RATING: 4.7

Books
TO READ

EMILIE DU CHATELET: DARING GENIUS OF THE ENLIGHTENMENT

The captivating biography of the French aristocrat who balanced the demands of her society with passionate affairs of the heart and a brilliant life of the mind.

 BY JUDITH P. ZINSSER

AMAZON RATING: 4.1

THE BOOK I DIDN'T WANT TO WRITE

In this genre-bending, deeply moving and unexpected memoir, Larher reflects on what the gruesome Paris Bataclan terror attack meant to him and to others.

AMAZON RATING: N/A BY ERWAN LARHER

DATELINE LIBERATED PARIS

BY RONALD WEBER

Vividly capturing the heady times in the waning months of World War II, Ronald Weber follows the exploits of Allied reporters as they flooded into liberated Paris after four dark years of Nazi occupation.

AMAZON RATING: 4.6

Because if you listen
well, in winter, there is
so much courage in the
song of the birds.

FRANÇOISE LEFÈVRE

*Françoise Lefèvre is a French writer discovered by publisher
Jean-Jacques Pauvert. She is a recipient of the Elle Wikipedia
Readers' Grand Prize.*

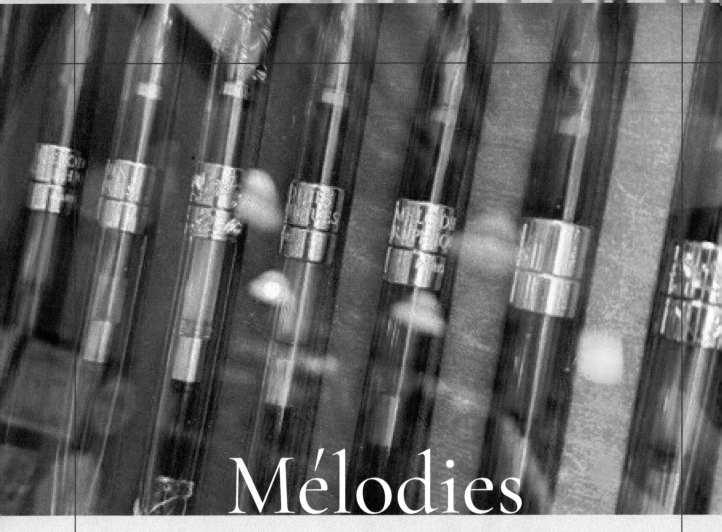

Mélodies Graphiques

Verba volant-Scripta manent is the Latin proverb for "Memory is lost but writing remains."

While Mélodies Graphiques first opened in 1986, the store has since changed ownership. When Giacomo and Hitomi first visited, they fell in love with the little Marais stationery shop.

"I told the previous owner that one day, I would love to take over the store so I could continue this great business."

A PLACE FOR LOVERS OF
paper and beautiful writing

A secret haven steps from the river Seine, this paper shop is like stepping back in time, a calm and creative haven in the middle of Paris.

Lose yourself amongst rows of stunning paper, ink wells of unimaginable colors, and the lost art of letter writing.

PASSION

"My wife and I are very passionate about classical painting and calligraphy and all handmade crafts. I have a degree in XIV-XV century art history and my wife in Japanese calligraphy. All the work of bookbinding and paper making and all the work of ancient calligraphy are of the masters of the King (Rossignol- Van de Velde-Barbedor...)"

AND PURPOSE

Giacomo and Hitomi's store draws visitors from around the world. Be sure to puruse their visitor book, where some test out the latest calligraphy pen offerings and artists scribble beautiful sketches. All guest books are carefully numbered and stored on a shelf in the back of the store.

Be inspired by Paris.

Two stores in one, Mélodies Graphiques spans two spaces, side by side, along the famous Rue du Pont Louis-Philippe.

Giacomo manages one side, taking custom orders for leather and paper-bound notebooks. I watched an eager couple gingerly pick out their favorite papers and notebook size. Giacomo smiled and told them to come back in fifteen minutes, and their Parisian token would be ready when they returned. He gently turns to me and takes a few more moments to show his handmade glass pens crafted in Paris and his leather stamping tools before returning to his projects.

Meanwhile, Hitomi is tucked into the other side of the shop, amongst stunning handcrafted notecards and gift sets. A visitor attempts to pick out a gift card, and Hitomi patiently translates each French phrase for their English-speaking customer. The husband and wife team are gracious hosts, full of charm, talent, and kindness.

> *Our store must continue to be a place for lovers of paper and beautiful writing.*

GETTING THERE

10 Rue du Pont Louis-Philippe, 75004 Paris

METRO: Pont-Marie

DISTANCE FROM THE SEINE RIVER: 2 minute walk

WEBSITE

INSTAGRAM

HOURS:
Monday 3 PM to 6 PM
Tuesday through Saturday
11 AM to 7 PM

Closed Sunday

SERVICES & OFFERINGS:

PERSONALIZED ITEMS
Custom notebooks in paper or leather, hand-stamped books, photo albums, guest books.

CORRESPONDENCE
Note cards and stationery, invitations, holiday cards, and personalized papers.

GIFT WRAP
Papers from France and Italy, large format and gift wrap, special occasion paper.

CALLIGRAPHY
Custom calligraphy upon request, pens, ink, and calligraphy supplies.

CUISINE & HOSTING

N.6

2022

WARM WINTER RECIPES

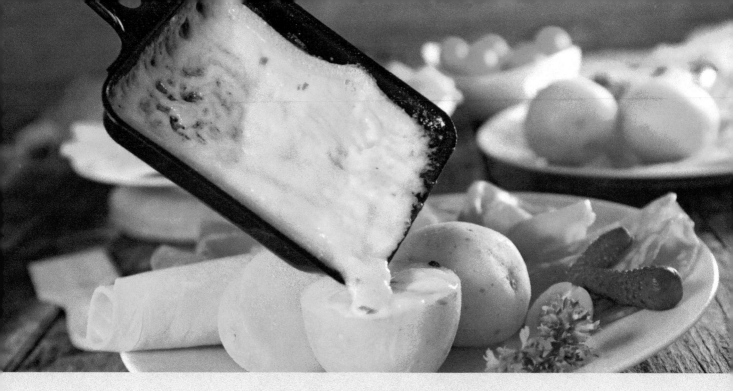

RACLETTE

Deep in the Valais ("Wallis" in German), you will find the origin of the raclette. But this isn't France! Valais is a canton in southern Switzerland and home to the pyramid-shaped Matterhorn mountain, upscale Alpine resorts, and upper Rhône River Valley vineyards.

The first traces of raclette, a favorite French winter meal, can be traced back to the Valais at the end of the 12th century. Until 1921, when the raclette oven was invented, these giant rounds of cheese melted carefully in the fireplace over logs.

Raclette was traditionally celebrated during a mid-August festival when the first cheese rounds were made. Sometimes cheeses from the different valleys and alpine pastures would have a parish priest come to bless them.

In 1964, during the National Exhibition in Lausanne, Valais introduced the whole of Switzerland and France to this dish. More than 13,600 tons of raclette cheese are produced annually in Switzerland, including more than 1,700 in Valais.

Just over the border of the Valais, you'll find the famous French village of Chamonix. The Savoie region became the origin of raclette as it extended into France. The largest raclette production is located in Brioude, France. The RichesMonts factory produced 65 tons per day. Vercouline is a raclette in which Vercors blue cheese is used. In Franche-Comté, Bleu de Gex (or Bleu du Haut Jura) and Morbier, both AOP, are used as variants.

Today, the trend for raclette parties is popular in France. You can easily find trays of sliced cheese in French grocery stores, made especially for raclette machines. Rather than melting a giant wheel of cheese, the electric machines (raclonette) heat up individual small spatulas full of your favorite condiments, melting in gooey French fromage. The raclonette is placed in the middle of the table and consists of an electric grill (or raclette oven).

yum!

Raclette

CHEESES

Choose Your Favorite

In addition to traditional Raclette cheese, you can use:
Camembert
Brie
Sharp Cheddar
Emmental
Gorgonzola
Gouda
Gruyère
Mozzarella, and
Monterey Jack

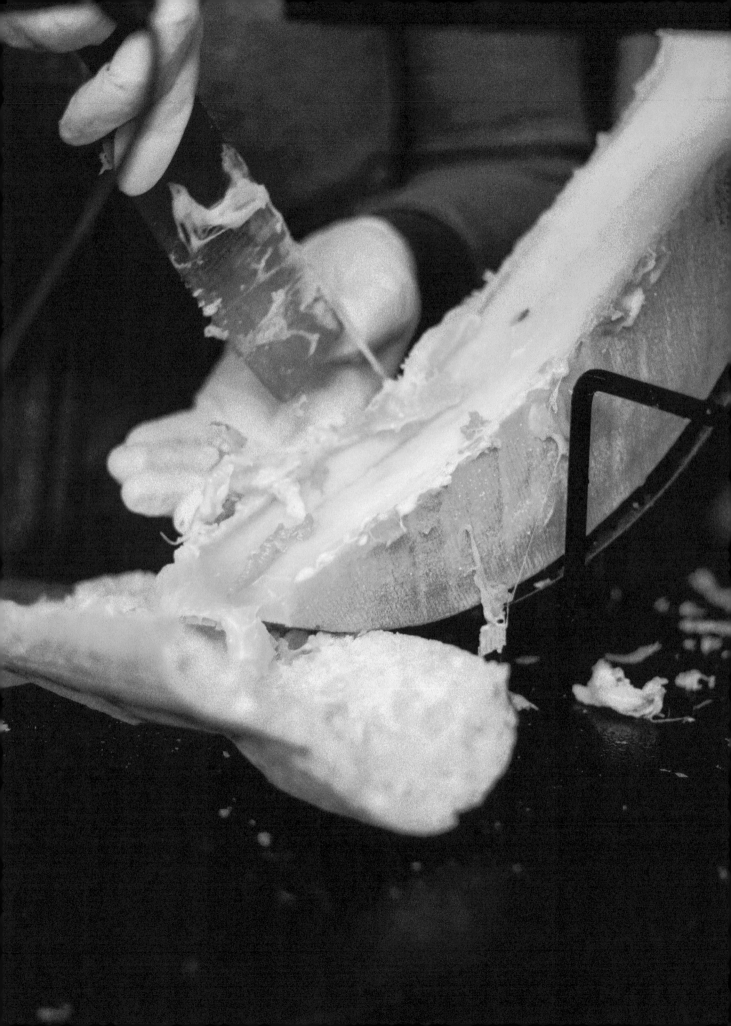

RACLETTE IN PARIS

Dusting off the cheesy traditions, MonBleu is new-wave raclette.

Damien Richardot, the founder of MonBleu Restaurant in Paris, grew up in the Alps in Chartreuse between Isère and Savoie. "Every morning, I drank fresh milk, still hot just after milking," he explains. "After, the would cheese arrive at our family table, and I developed a taste and knowledge at a young age."

Studies took Damien far from the mountains - to New York, where he became a strategic consultant and eventually moved back to Paris. "In 2016, I decided to return to my first love and dive into this world of cheese that had made me dream so much for a long time," shares Richardot. "I go to meet producers, craftsmen, and traders abroad, especially in France's four corners. I then discovered Pierre Gay, who shared his passion and knowledge of cheese with great generosity. A friendship was born around a common passion."

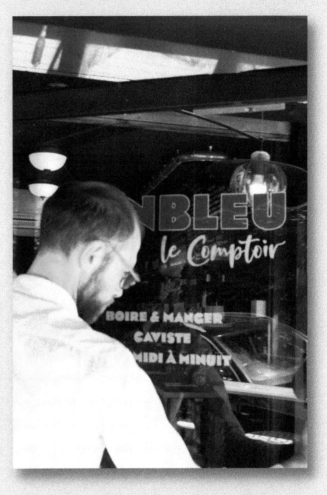

There are now two MonBleu locations in Paris and a third one on the way. A few minutes from the Grands Boulevards, Monbleu Faubourg Montmartre is a restaurant and cheese shop. Book a table online to discover their menu around cheese and good seasonal products. And to accompany it all: craft beers and an extensive wine list.

PHOTO CREDIT: MONBLEU

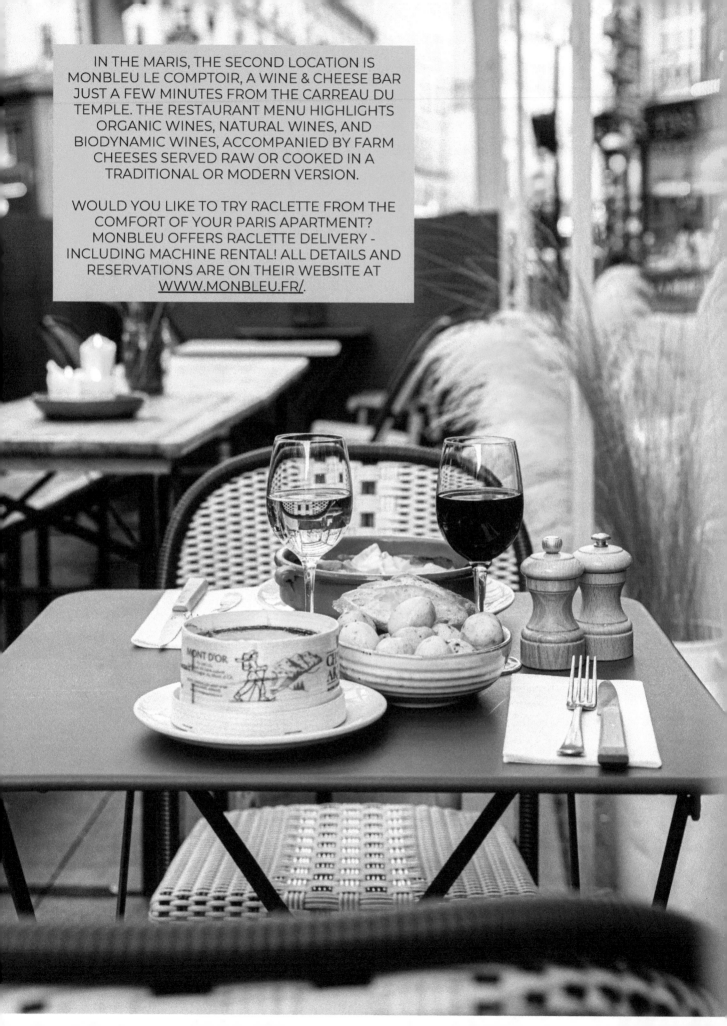

IN THE MARIS, THE SECOND LOCATION IS MONBLEU LE COMPTOIR, A WINE & CHEESE BAR JUST A FEW MINUTES FROM THE CARREAU DU TEMPLE. THE RESTAURANT MENU HIGHLIGHTS ORGANIC WINES, NATURAL WINES, AND BIODYNAMIC WINES, ACCOMPANIED BY FARM CHEESES SERVED RAW OR COOKED IN A TRADITIONAL OR MODERN VERSION.

WOULD YOU LIKE TO TRY RACLETTE FROM THE COMFORT OF YOUR PARIS APARTMENT? MONBLEU OFFERS RACLETTE DELIVERY - INCLUDING MACHINE RENTAL! ALL DETAILS AND RESERVATIONS ARE ON THEIR WEBSITE AT WWW.MONBLEU.FR/.

WHERE TO RACLETTE
IN PARIS

MONBLEU Faubourg Montmartre
37 Rue du Faubourg Montmartre, 75009 Paris

MONBLEU Le Comptoir
12 Rue Dupetit-Thouars, 75003 Paris

Les Marmottes
26 Rue de la Grande Truanderie, 75001 Paris

Le Chalet Savoyard
58 Rue de Charonne, 75011 Paris

Le Vieux Bistrot
54 Rue Mouffetard, 75005 Paris

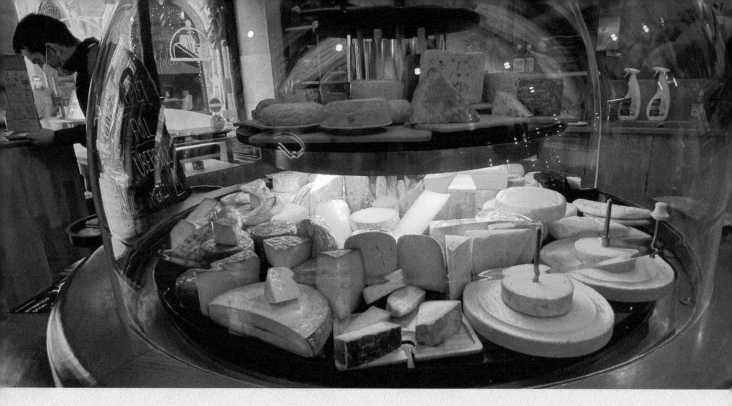

THE RACLETTE MADE OF DREAMS

CLOCHE À FROMAGE

Founded in 1988 by René Tourrette, Cloche à Fromage earns its name from the stunning glass dome that greets you as you enter the restaurant, recognized as the largest in the world by the Guinness Book Records in 1989.

When I planned our trip to Strasbourg last year, this restaurant continually landed on all of the top lists. To the point that even though my trip was three months away, there was only ONE open table during our stay. And I have been pining to go back ever since.

Cheese connoisseurs, novice amateurs, and the simply curious are all welcomed here by their expert staff. The "cloche" (French for "bell") houses up to ninety different kinds of cheese for you to explore and taste.

ADVANCED RESERVATIONS REQUIRED.

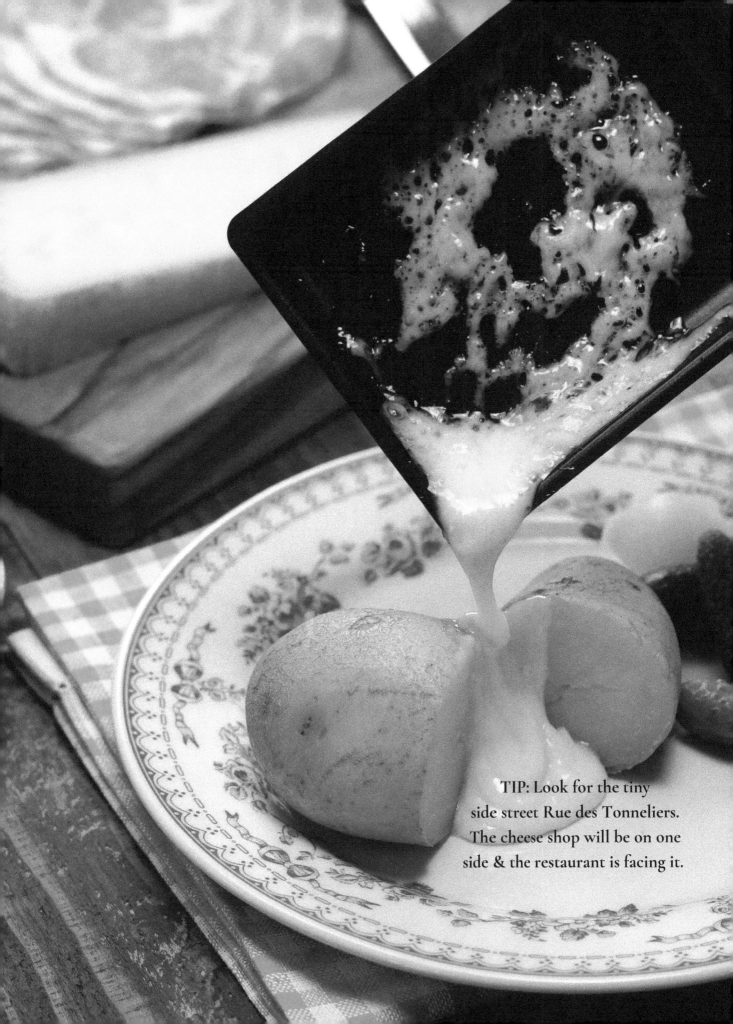

TIP: Look for the tiny side street Rue des Tonneliers. The cheese shop will be on one side & the restaurant is facing it.

But I was here for the raclette. A team member arrives at your table and sets up the "oven," a traditional metal appliance meant to heat a half-wheel of raclette cheese.

The staff speak French and English and explain how to use the machine to heat and serve yourself the gooey cheese over meat, potatoes, and other condiments.

The entire adventure was unforgettable. Cloche à Fromage offers a fantastic wine list, the meal was superb, and the space was cozy and comfortable for an extended dining experience. They even accepted Pearl and Rose in the restaurant!

contact

CLOCHE
À FROMAGE

WEBSITE

instagram: @laclocheafromage

RÉSERVATIONS

Cheese To Take Away

La Cloche also has multiple cheese shops that you can visit. There are three in Strasbourg, another three locations around this village, one in Epernay (Champagne) and a location in the south of France, Montpellier.

VIDEO

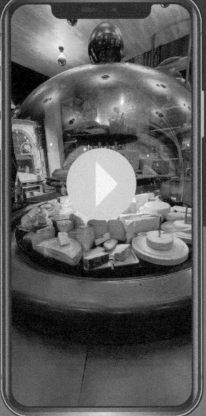

Restaurant Video

In this video, I share my experience at Cloche à Fromage.
I would travel to Strasbourg just for this meal!

WATCH NOW

DIY RACLETTE
& FONDU PARTY

Take the pressure of holiday hosting by serving up raclette and fondu this season. Comforting, cozy, and a crowd-pleaser, your guests will be talking about this fun experience for a long time.

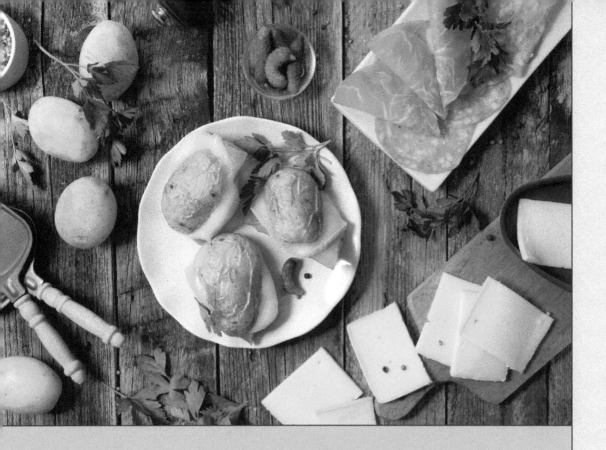

Party Preparations, Tools, & Pairings

First, you'll also want to choose a machine with good ratings for melting the cheese efficiently. I found <u>this affordable version</u> that has a six or 8-person option.

For fondu, ensure the pot has high sides to avoid splatter and adjustable seat settings so that the meat or chocolate does not burn. Two color-coded forks per person are usually enough.

Finally, an extension cord is an excellent tool, so cables don't get in the way. If guests will be stepping over the cord, tape it to the floor, so no one trips.

Wine pairings for raclette should be white wines such as Saint-Véran or Mâcon from Burgundy. I also love Crozes-Hermitage. A meat fondu should be paired with reds such as a Brouilly or Morgon from the Beaujolais region.

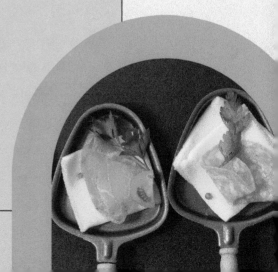

Raclette Party Ideas

Get ready for giggles! This is such a fun activity for all ages.

01 THE CLASSIC RACLETTE

Melt your preferred cheese and serve with pickles, meat, and boiled potatoes.

02 RACLETTE WITH VEGETABLES

Serve the raclette with diced tomato, peppers, mushrooms, avocado, and potato.

03 NORDIC RACLETTE

This variation is served with slices of smoked salmon and prawns.

04 SEAFOOD RACLETTE

Brown onions, garlic, mushrooms and shrimp in a pan. Drizzle with white wine. Season with salt, pepper, lemon juice, & add fresh herbs.

05 AN ITALIAN RACLETTE

Accompany the cheese with pancetta, coppa, bresaola, mortadella, Parma ham, olives and grilled peppers.

06 DESSERT RACLETTE

Serve with fresh fruit cut into slices: apples, pears, chocolate, and tangerines.

Appetizer Option

While raclette can be a hearty main dish, you can also serve the melted cheese as an appetizer.

Fondu in rural France

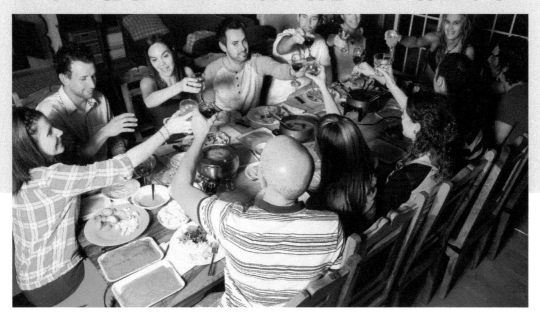

Denis

If you have followed me for some time, you know that I own a house in the countryside of France. The little stone cottage doesn't have any immediate neighbors, but the closest one is the best one this American gal could ever ask for - Denis.

Denis takes up space, real and perceived; with his booming voice, he barks orders to anyone near him. He is a retired farmer and head of the local chasse (hunt unit) and, for some reason, has taken me under his wing.

I wait patiently for each invitation for fondu at his house. I have never seen the man eat anything other than pork, game meat, bread, and potatoes. Like how he operates his humongous blue tractor, Denis efficiently moves through the kitchen and points at what he wants me to do.

We always start with his homemade paté. I have never been a fan of this dish before, but whenever he hands me a new jar of his homemade sanglier (boar) paté to take home, I greedily giggle over the treat. Denis carves giant slices of fresh, crusty country bread from the next village over - he refuses to buy anywhere else from this one baker. His mother loves the riz au lait.

As we snack, Denis heats the fondu oil on the cooktop and disappears into the back room to turn on the fryer. Locals come and go from his house as if it were a bar restaurant. Some pop in just to say hello, others have business to discuss, and some are here for lunch too. Denis' house is a hub of the village. Eventually, he pops a bottle of red wine and dumps the hot oil into the fondu pot. We each choose two forks with the same color, and he delivers a plate heaping full of brilliantly red biche meat - deer.

I crave this meal just as much as I can think of any other. It's one of my favorite experiences in Bretagne. Denis returns from the back room with another plate full of fresh french fries. Sometimes his mother and I spend time together cutting them by hand, her thick fingers deftly carving up two or three to my one.

We get to talking about the price of gas, the wild turkeys he saw a couple of fields over, when the next chasse meet up is going to happen, and what's happening next for my home renovations. And then he'll cluck at me, winking, "Don't overcook that meat."

Lunch ends almost as quickly as it starts. He sometimes offers some puddings from the fridge. Otherwise, "Bon..." is the way Denis ends all conversations and events. We get up from the table, I help with the dishes, and happily waddle back home, wondering when the next invitation will come my way.

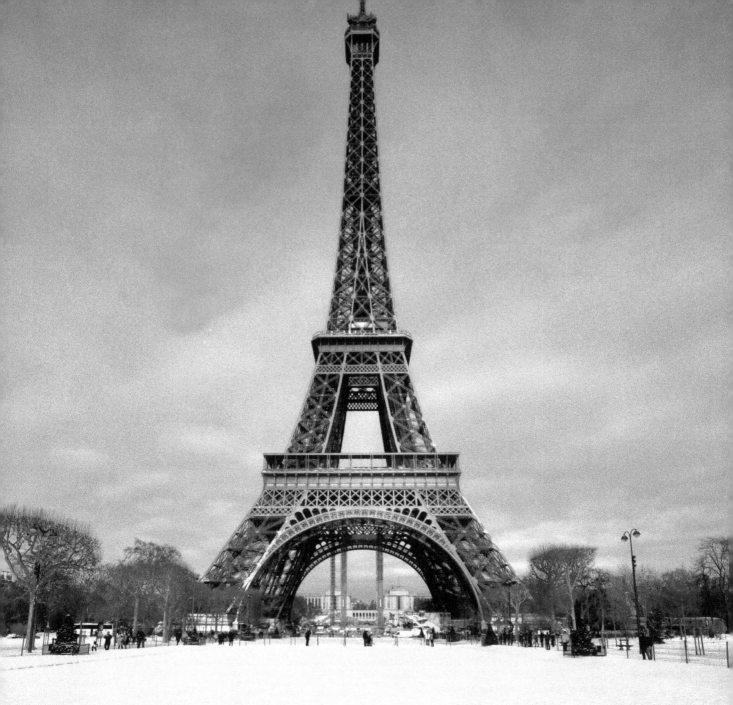

"Add two letters to Paris:
it's paradise."

JULES RENARD

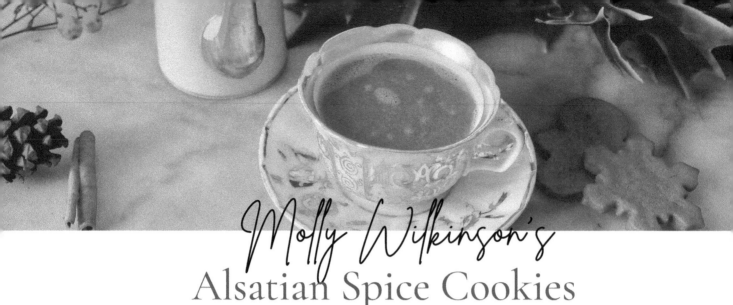

Molly Wilkinson's
Alsatian Spice Cookies

Difficulty: ★ ☆ ☆ ☆ ☆ **Prep time:** 10 min **Bake time:** 12 min **Servings:** 24

INGREDIENTS

¾ cup (150 g) brown sugar
(light or dark), packed

6 tbsp (85 g) unsalted butter,
room temperature

1 large egg, room temperature

1 tsp vanilla extract

1 ½ cups (190g) all-purpose flour

½ tsp baking powder

½ tsp ground ginger

1 ½ tsp ground cinnamon

¼ tsp ground cloves

Pinch of salt

DIRECTION

1 Preheat your oven to 350F/175C. In an electric mixer fitted with the paddle attachment or with a hand mixer, beat together the butter and sugar for several minutes until light and fluffy. Mix in the vanilla and egg.

2 In a separate bowl, whisk together the remaining ingredients (flour, spices, baking powder, and salt). Slowly add these to the mixing bowl in several additions and beat until the dough comes together.

3 Bring together as a ball. Flour your surface and roll out the cookie dough using gentle pressure to a little less than ¼ inch thick (4mm). Cut out cookies using cookie cutters and transfer to a parchment lined baking sheet leaving about an inch (2.5cm) of space around each cookie.

4 Bake 10-12 minutes until firm across the surface. Transfer to a cooling rack and cool completely.

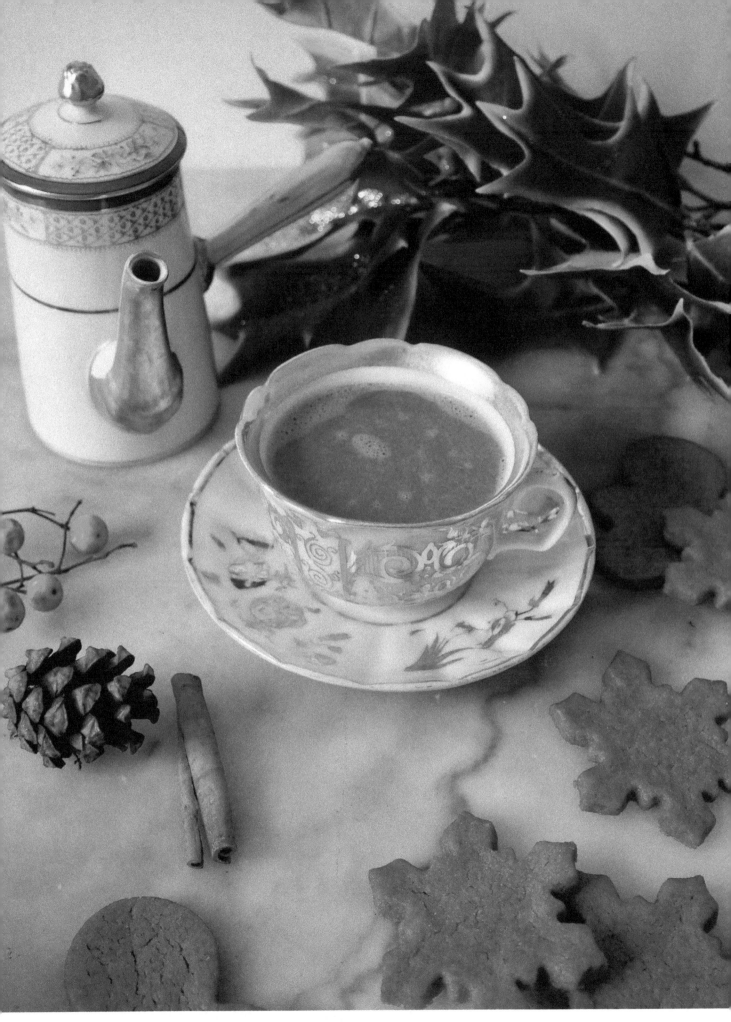

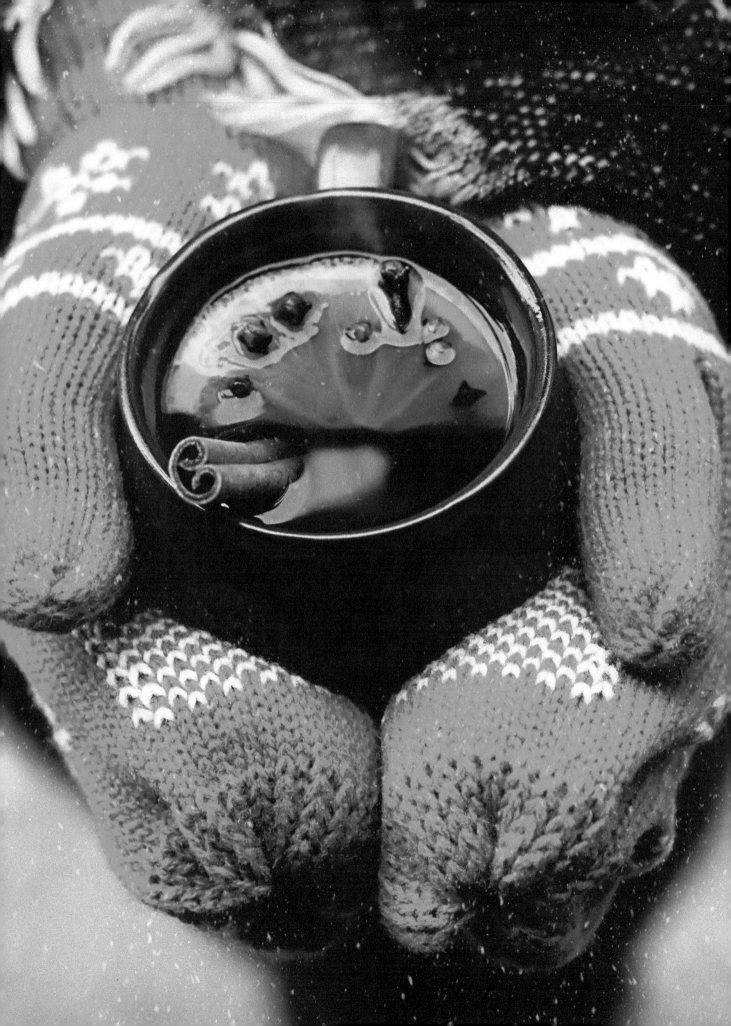

Make This

Vin Chaud (Mulled Wine)

Difficulty: ★ ☆ ☆ ☆ ☆ **Prep time: 10 min** **Bake time: 12 min** **Servings: 24**

INGREDIENTS

1 bottle of red wine
1 star anise
100 g of sugar
2 cinnamon sticks
3 cloves
10 black peppercorns
zest of 2 oranges
zest. of 1 lemon
1 small piece of minced ginger (optional)

NOTES

When picking a bottle of French wine for this recipe, try Côtes-du-Rhône, a Merlot, Pinot noir or a Bordeaux varietal.

DIRECTION

1 Pour the wine into a non-reactive saucepan. add the star anise and heat the wine on medium. Careful to not let it boil!

2 Add the remaining ingredients, stirring to combine.

3 Let the mixture simmer over low heat for 20 minutes. Strain and serve hot.

Serve with a cinnamon stick, a slice of orange, and a star anise as a fun garnish.

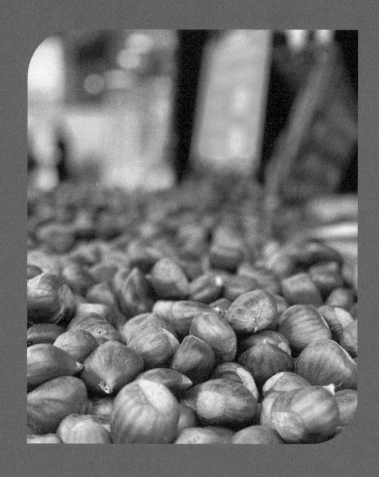

Take your moment
to live, take your
moment to love

Winter
DINNER

DOWNLOAD A BLANK VERSION OF THIS MENU DESIGN HERE.

APPETIZERS

Foie gras
Oysters & Escargot

ENTREES

Bone-in Prime Ribeye
Herb Roasted Turkey Breast

DESSERTS

Alsatian Spice Cookies
Bûche de Noël

DRINKS

Vin Chaud
Sparkling Water

PARISIAN DELIGHTS

N.6

2022

EAT & DRINK

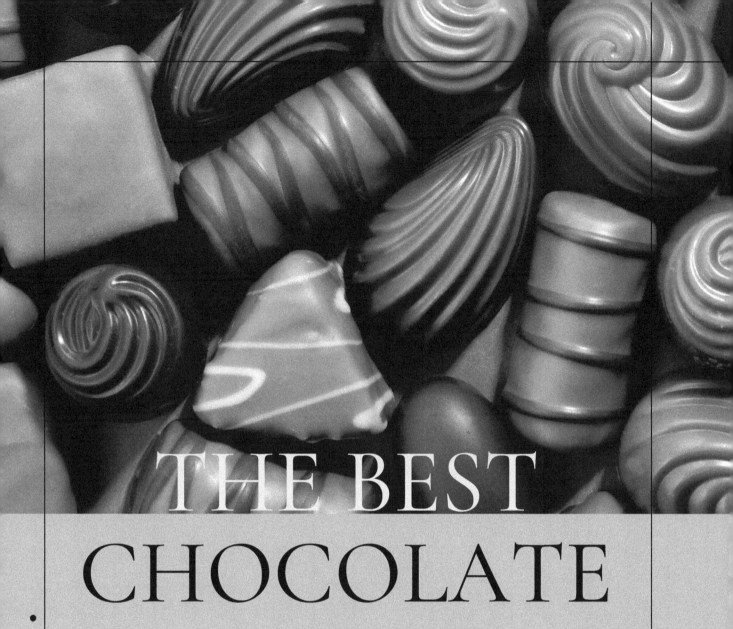

THE BEST
CHOCOLATE

It is no secret that Paris is home to some of the most talented chocolatiers in the world. Indeed, we owe the democratization of chocolate in France to Anne of Austria, who married Louis XIII in 1615 and spread this treasure throughout the Palace of Versailles. A few years later, in 1671, Louis XIV opened the first Parisian store selling "drinking chocolates."

And did you know that there is a chocolate museum in Paris? OUI! The <u>museum</u> focuses on chocolate's origin, evolution, and consumption through a collection of a thousand objects. It presents the historical aspect of chocolate, the development of manufacturing methods, and the ingredients used. Enjoy this sweet section on the best chocolatiers in Paris right now.

Chocolate in Paris

Chocolate is an excellent gift that travels well during the winter months. Try to purchase right before you depart so it's super fresh upon arrival.

1

PATRICK ROGER

2
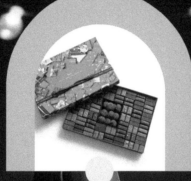

LA MAISON DU CHOCOLAT

3
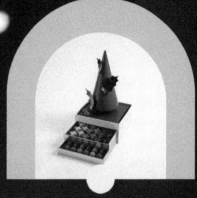

PIERRE MARCOLINI

4

CHOCOLAT BONNAT

5
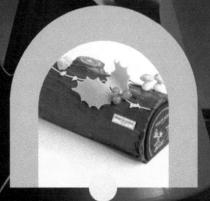

SEBASTIAN GAUDARD PATISSIER

6

HUGO & VICTOR

CLICK THE PHOTO FOR DETAILS.

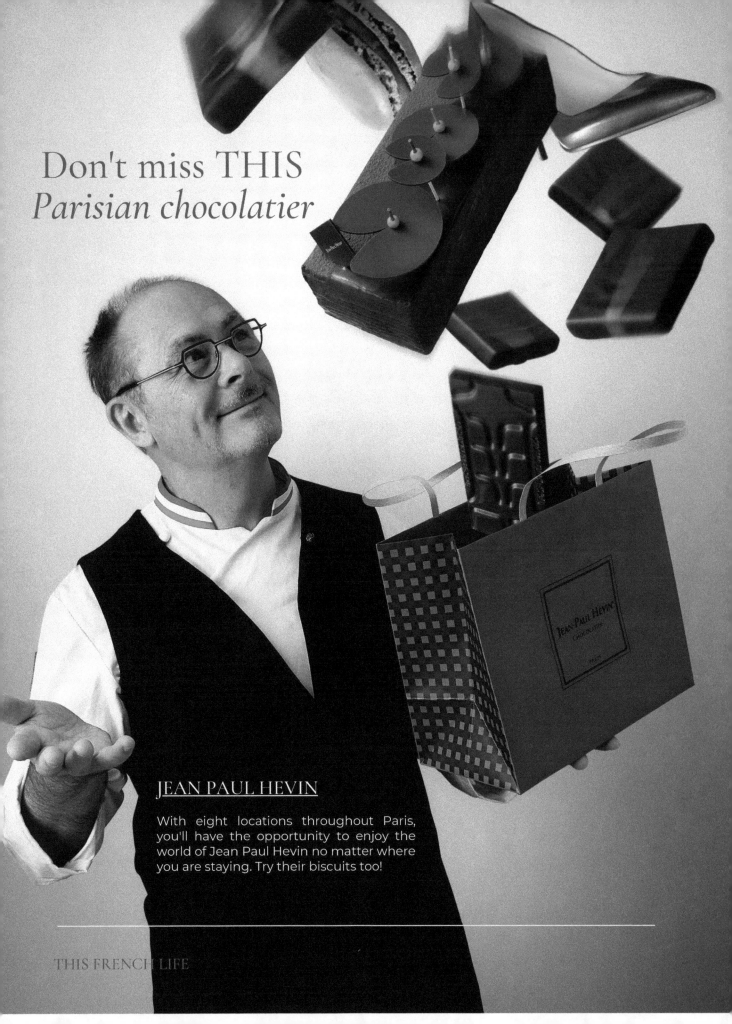

Don't miss THIS
Parisian chocolatier

JEAN PAUL HEVIN

With eight locations throughout Paris, you'll have the opportunity to enjoy the world of Jean Paul Hevin no matter where you are staying. Try their biscuits too!

HOT Cocktail Spots

FREQUENCE PARIS

@frequencyparis

20 Rue Keller, 75011 Paris

Relaxed haunt with a cool vibe offering cocktails, tapas & shelves of vinyl records behind the bar.

LE SYNDICAT

@lesyndicat

51 Rue Faubourg StDenis, 75010

"Where Grandpa spirits go Gangsta." Hip hop. Ranked 45 best bar in the world.

CAMBRIDGE

@thecambridge_paris

8 Rue de Poitou, 75003

On World's best bar list. Traditional English bar with creative cocktails and a rotating pub grub menu.

ANIMAUX BARS

@animauxbars

THREE LOCATIONS IN PARIS

Intimate, thematic, and cozy bars with custom and classic cocktails, finger foods, and great customer service.

ILE DE FRANCE

Cocktail Recipe

BUILD IN A CHAMPAGNE GLASS:
1/2 TSP FINE SUGAR
1/2 PONY COGNAC

Fill dry Champagne, chilled
Top with 2 dashes yellow Chartreuse
SERVE!

Beautiful
BRASSERIES

GRAND CAFÉ
CAPUCINES

Created during the inauguration of the Opéra Garnier in 1875, the Grand Café Capucines quickly became an essential place on the Grands Boulevards. Oysters, Parisian-style lobster and seafood platters can be enjoyed daily from 7 am to 1 am. Consider this location for an after-show dinner too. Details <u>here</u>.

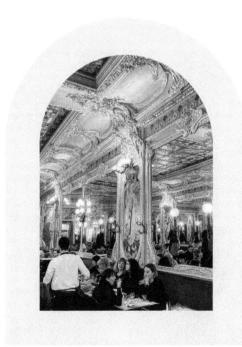

BOUILLON
JULIEN

"Here, Everything Is Beautiful, Delicious And Great Value," claimed Edouard Fournier, founder of Bouillon Julien (1906). And not much has changed since. Bouillon Julien is one of the most beautiful restaurants in Paris, if not the world. It remains one of the best preserved examples of the Art Nouveau style. Details <u>here</u>.

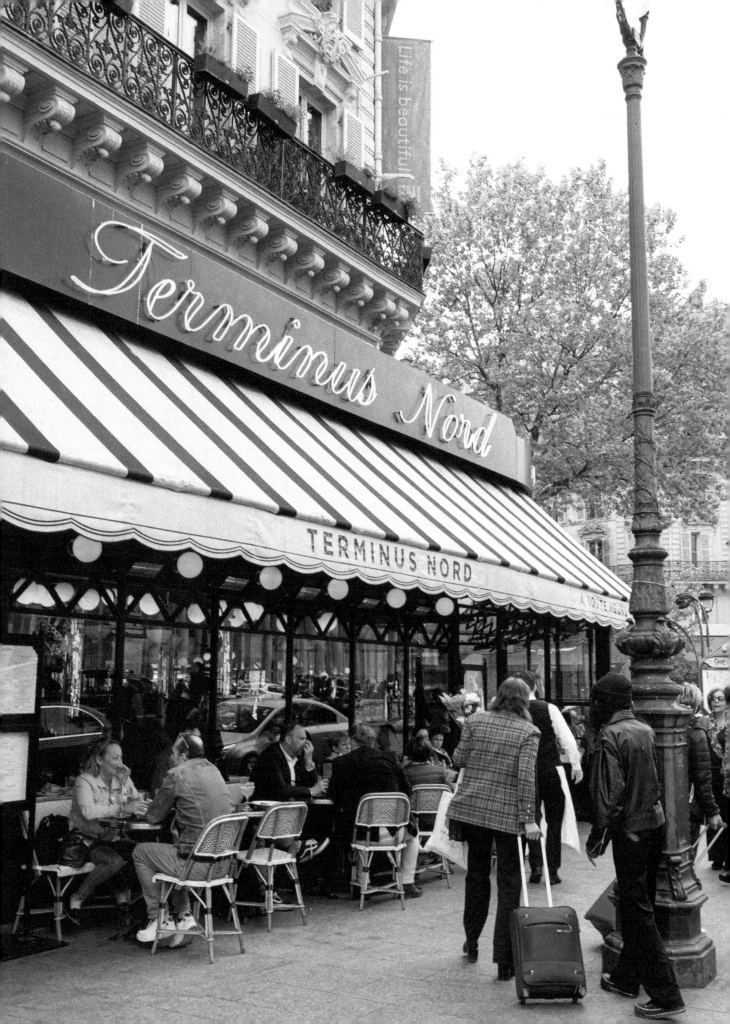

Beautiful
BRASSERIES

BRASSERIE

VAGENENDE

Admire the glass roof covering an old interior courtyard, the earthenware with braided fruit motifs, or the 36 landscapes painted on molten glass created and signed by Pivain while enjoying classic French dishes. Details <u>here</u>.

BRASSERIE

FLODERER

FLODERER is the original name of the first brasserie known as FLO, Cour des Petites Ecuries in Paris. Founded by two Alsatians who fled their region after the annexation by Germany at the end of the 19th century, this institution quickly became one of the most prestigious brasseries in France. Click <u>here</u>.

TERMINUS

NORD BRASSERIE

This Parisian brasserie has been inviting you since 1925 to enter Paris through the gourmet gate. Businessmen leaving for London, travelers returning from Brussels, families, everyone meets at the Northern Terminus: the liveliest of the Grandes Brasseries. Details <u>here</u>.

"IT'S NOT HOW MUCH WE GIVE BUT HOW MUCH LOVE WE PUT INTO GIVING."

Mother Theresa

Six Great Places with FIREPLACES

Auberge du Bonheur

Atelier Maître Albert

Le Flamboire

Auberge du Bonheur is renowned for its magnificent garden open all summer long. In winter, the Auberge du Bonheur takes on a completely different face and turns into an elegant chalet where it is good to snuggle up by the fireplace while enjoying traditional French cuisine.

In a building dating back to 1400 just steps from Notre Dame, enjoy a crackling fireplace in the monumental fireplace at this Guy Savoy restaurant. The bar-wine library lends itself particularly well to large tables and its large wine libraries invite you to taste some fine bottles from the cellar.

In an atypical Paris setting, enjoy the huge wood-burning fireplace in the background while grill Chef Jean-Yves Chesneau prepares a meal before your eyes. Featuring meats from Aubrac, there is also fish options. Warm & friendly atmosphere. Try the Chateaubriand and chocolate mousse.

CLICK PHOTO FOR DETAILS

Six Great Places with
FIREPLACES

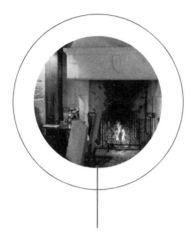

Le Jardin de Montreuil

With a hidden interior garden, piano, and fireplace, you'll find respite at this restaurant year-round. Open for both lunch and dinner Tues-Saturday, the food is simple, approachable, and fresh. Be sure to check their Instagram for jazz night events.

Le Coupe Chou

The Coupe-Chou is composed of four houses dating from the 14th, 16th and 17th centuries. Founded in 1962, Coupe-Chou specializes in French cuisine 100% made in house. Open Dec 24th, 25th & 31st to offer you the best Christmas Eve ever!

Hotel au Busson

In 1947, this mythical venue in Saint-Germain-des-Prés stayed open throughout the night. Today, jazz evenings continue from Monday to Saturday, no longer in the formerly packed cellars, but in a lounge offering a cosy fireplace atmosphere.

CLICK PHOTO FOR DETAILS

Vin Chaud

There's nothing like wandering the streets of Paris during the holidays while sipping on a cup of vin chaud (mulled wine) or chocolate chaud (hot chocolate). Here is where to find the best!

1

THE ABBESSES CHRISTMAS MARCHÉ, MONTMARTRE

2

CAFÉ SAINT REGIS, ILE SAINT LOUIS 75004

3

CAFÉ DE FLORE, 172 BD SAINT GERMAIN, 75006

4

LA CLOSERIE DES LILAS, BD DU MONTPARNASSE

5

CHEZ GEORGES, 11 RUE DES CANETTES, 75006

6

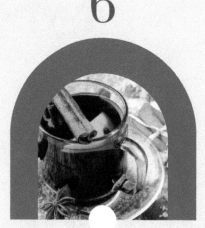

Or grab a DIY vin chaud kit at the Grande Epicerie here.

LE CONSULAT

RESTAURANT LE CONSULAT

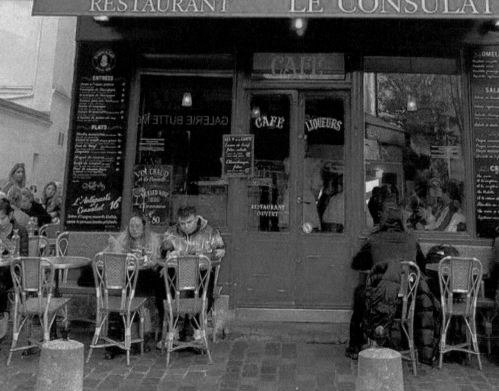

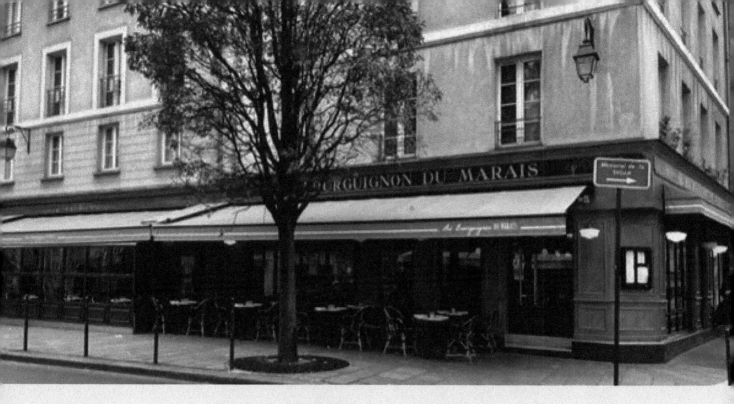

French Winter Comfort Food
AU BOURGUIGNON DU MARAIS

In my not-so-humble opinion, this restaurant has everything one could ask for in Paris: top-notch service, fantastic quiet Marais picturesque corner just a block from the Seine, affordable prices, and a menu full of the best French classic recipes. With easy online reservations, Au Bourguignon should be at the top of your list.

A family owned and operated business, Au Bourguignon du Marais is primarily a father and son team. You will find Elie Delcher, the pére, and his two fils, Jonathan and Antoine, managing daily operations. And Valérie is the maitress behind the scenes.

Elie focuses on the wine program at the restaurant. He chooses exclusively wines from great and small producers. And the menu is a mix of traditional Burgundian cuisine by Chef Thierry Blanchet, who worked for 12 years on the Orient Express.

I chat with Jonathan whenever I can. Tall and handsome, he is a gentle soul that loves to take care of every customer who walks through their doors.

The family comes from a long line of restauranteurs, including their two grandmothers. They chose Le Marais for its authenticity and preserved historical authenticity.

Au Bourguignon du Marais has been in business since 1992. "A piece of furniture from my maternal grandmother's restaurant faces the the front door, I am very proud of it!" exclaims Valérie. "We are now at the head of a beautiful ship that I hope will sail for a long time!"

book now

Au Bourguignon
DU MARAIS

WEBSITE

01 48 87 15 40

ONLINE RESERVATIONS HERE

What to Expect

Cozy classics that will warm the soul and belly including french onion soup, jambon persillé de Bourgogne, oeufs pochés en meurette, escargots, le Boeuf Bourguignon «tradition », and gorgeous profiteroles with Berthillon vanilla ice cream.

An Inclement
Weather Itinerary

PURCHASE YOUR MUSÉE JACQUEMART ANDRÉ TICKETS ONLINE.
° 10 AM - ARRIVE AND VISIT THE MANSION
° 11:45 AM - THE SALON OPENS FOR LUNCH
° 1:30 PM - TAKE THE MIROMESNIL LINE 9 METRO TO THE
RICHELIEU-DROUOT STOP, AND WALK TO THE LIBRARY.
° 2 PM - VISIT BNF AND ITS TEMPORARY EXHIBIT OR MUSEUM.
° 2:45 PM - WALK THROUGH GALERIE VIVIENNE.
° 3:15 PM - WALK A HALF BLOCK UP TO PALAIS ROYALE AND GRAB
A WARM BEVERAGE AT CAFÉ KITSUNÉ.
° 3:45 PM - WANDER THROUGH THE PARK.
° 4:15 PM - CROSS THE STREET TO VISIT THE MAD.

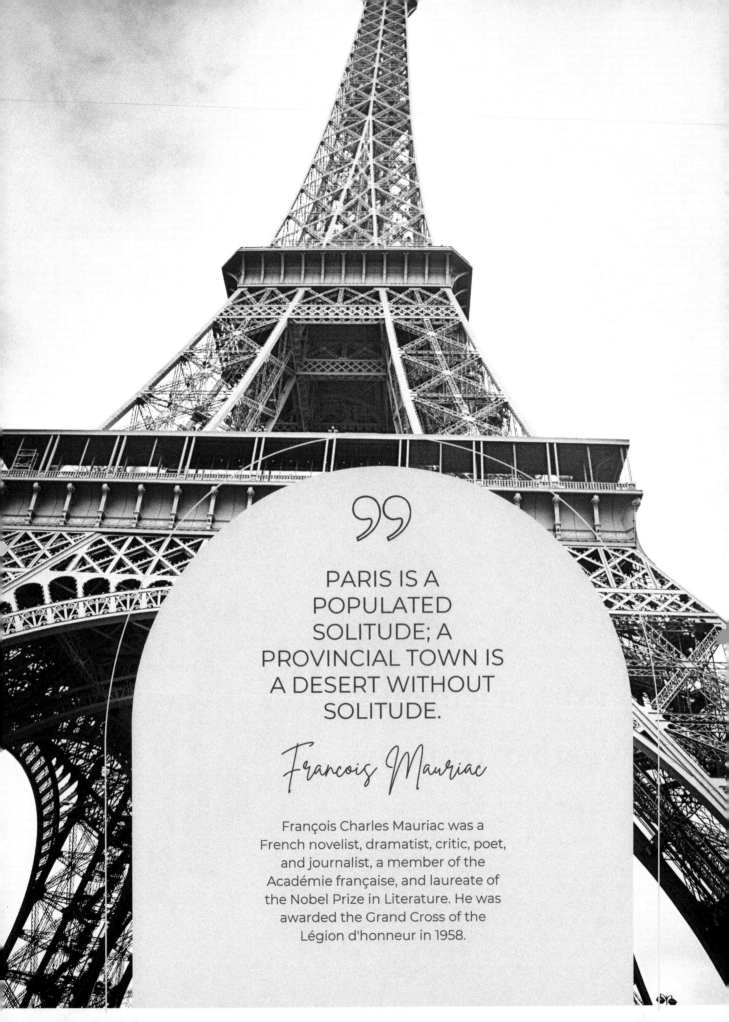

> ## PARIS IS A POPULATED SOLITUDE; A PROVINCIAL TOWN IS A DESERT WITHOUT SOLITUDE.

François Mauriac

François Charles Mauriac was a French novelist, dramatist, critic, poet, and journalist, a member of the Académie française, and laureate of the Nobel Prize in Literature. He was awarded the Grand Cross of the Légion d'honneur in 1958.

BE INSPIRED

N.6

2022

FRENCH ARTISTS TO KNOW

Floral Dreams

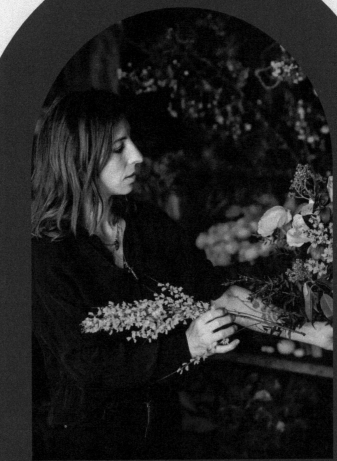

AUDE ROSE FLORIST

<u>WEBSITE</u>

INSTAGRAM: @auderose

24 avenue Édouard Vaillant
92150 SURESNES

PHOTO CREDIT: @ REBECCA VAUGHAN COSQUERIC

A faded wall, a cracked vintage plate, Aude finds inspiration in the colors that pass and patinate, creating living baroque art with fresh flowers & light.

"I grew up in Suresnes in a bourgeois family far from the commercial world. My aesthetic sensitivity was influenced by my parents' love of flea markets, visits to castles and regular trips to museums. I have never stopped chasing this aesthetic ideal that inhabits me, I have been refining for years what I believe to be the bottom of my soul, and I am constantly getting closer to what I believe to be the quintessence of my universe." - Aude ANGLARET

PHOTO CREDIT: @ JULIE BLIN

TELLING STORIES WITH FLOWERS

I work on this style, modeling it as time goes by - as I meet new people, and as my team & I take on new challenges. I am a devourer of images; I decorate with the colors and textures of all the works that challenge me.

ADAPTING TO CHANGE

The Covid period was not easy but there was a real sense of solidarity. People were very sedentary during that time, and because of our status as a neighborhood business in a very residential town, we had great traffic and success.

It is with the exit of Covid which was complicated! Today, inflation is impacting the cost of plants and we must redouble our creativity; to emphasize each flower, to avoid losses, to work each flower as a luxury product.

Each one is precious, and this makes me change the way I used to look at plants. Do we have to wait for the price to go up to realize the value of plants? The impact of their production? I find that every crisis is an opportunity to reinvent oneself and my goal is to find shorter supply chains and develop more conceptual artistic projects.

THIS FRENCH LIFE PHOTO CREDIT: @ JULIE BLIN

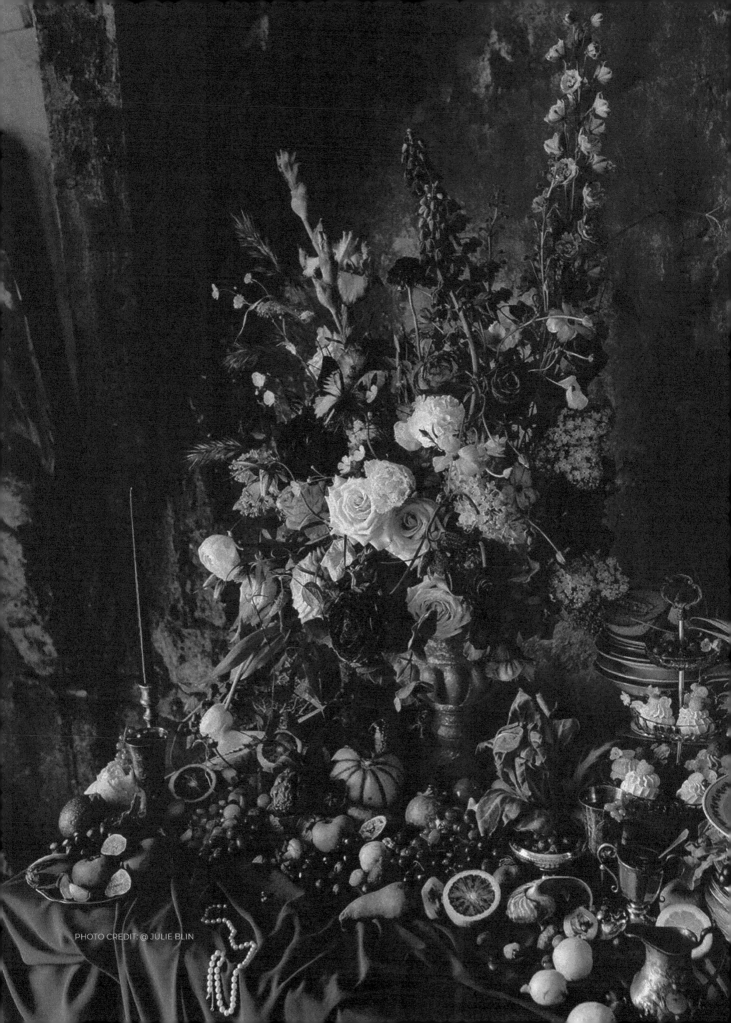

"

I am currently obsessed with the work of one of our contemporaries, Roberto Ferri. I love the inspiration of the ultra classic seen from his prism. Dealing with the nude, very dramatic-theatrical positions, with very heavy messages and resolutely modern.

SPACES & PLACES

I love the galleries of the Château de Chantilly and the Musée d'Orsay. Yes, there are paintings that obsess me.

But more than an artist or a particular painting, they are atmospheres. I like the clair-obscur, the game between life and death.

Ultra bright flowers near a skull on a dark textured wall and almost burned. I love this contrast.

The whole still life thing, a butterfly, a copper vase that steals all the light, and that bouquet feel of the king's gardener.

I love giving symbols, depth to my work. To intrigue and use curious, atypical flowers and at the same time mix them with great classics. In short, my floral work is very cerebral!

Abandoned places make me cry with beauty! The penetrating vegetation, the crumbling walls, the danger and the poetry that reign there.

The last photoshoot we did with my team was an abandoned place. I can tell you that when I saw the patina of this wall, the worm-eaten floor, heard the slammed windows, the pigeons in the roof, the smell of dust... I imagined my flowers laying there so well.

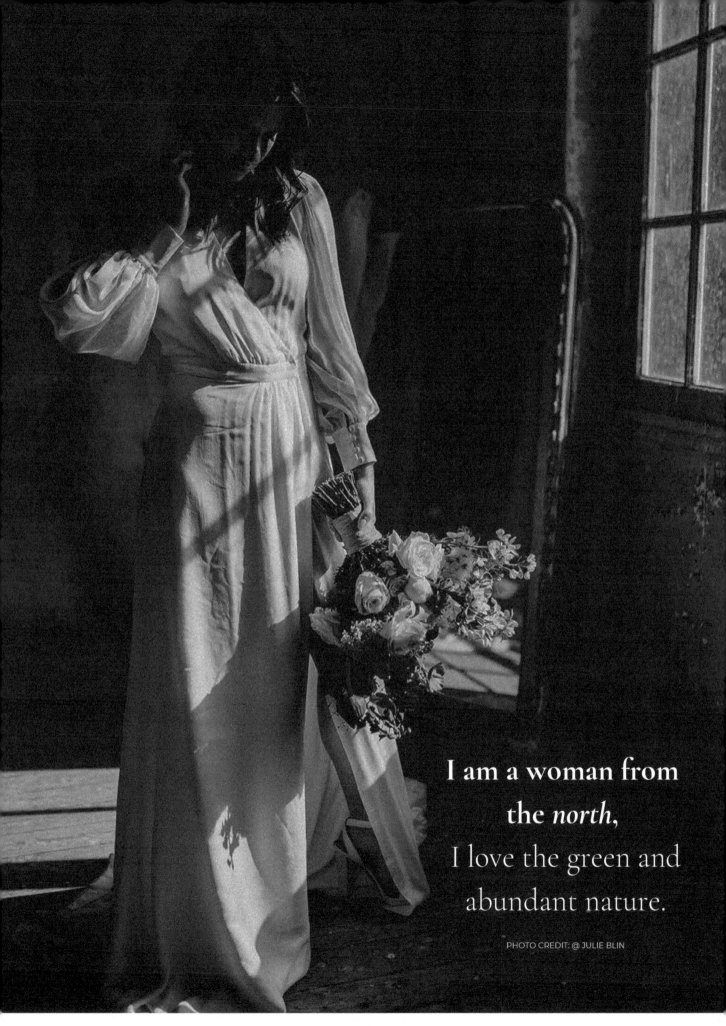

I am a woman from
the *north*,
I love the green and
abundant nature.

PHOTO CREDIT: @ JULIE BLIN

> We care about communicating that we are a "safe-place" for the LGBTQUIA+ communities, and that they will be welcomed and not judged.

trés joli

Aude Rose delivers to all of Paris and her suburbs. Additionally, her team can offer two-hour delivery within the west of Paris and to the 92nd district.

Aude Rose also offers an English-speaking advisor for the telephone exchanges and they accept orders by e-mail too!

WEBSITE
INSTAGRAM
EMAIL:
boutique@auderose.fr
ONLINE CONTACT FORM
PHONE: 01 47 72 49 31

Details & How to Order

TO BE PARISIAN IS NOT TO BE BORN IN PARIS, IT IS TO BE REBORN THERE.

Sacha Guitry

Alexandre Guitry, known as Sacha Guitry, is a French playwright, actor, director, director and screenwriter, born on February 21, 1885 in Saint-Petersburg (Russia) and died on July 24, 1957in Paris. A prolific playwright, he wrote one hundred and twenty-four plays, many of which were big hits. He has also made thirty-six films (including seventeen adaptations of his plays), acting in almost all of them.

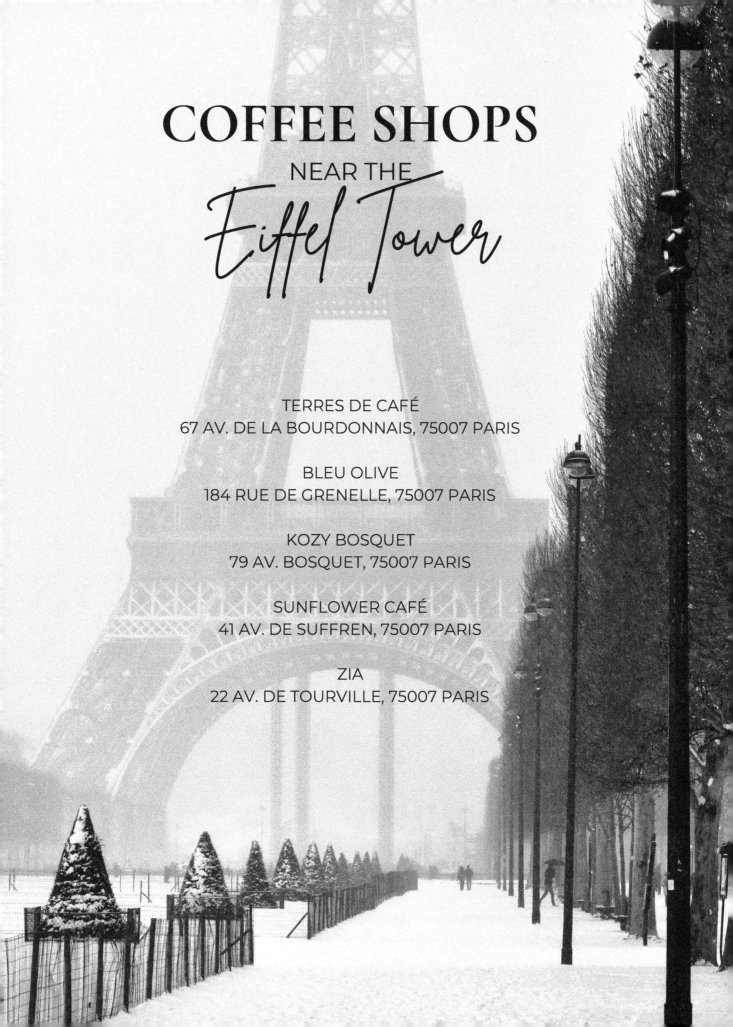

COFFEE SHOPS

NEAR THE

Eiffel Tower

TERRES DE CAFÉ
67 AV. DE LA BOURDONNAIS, 75007 PARIS

BLEU OLIVE
184 RUE DE GRENELLE, 75007 PARIS

KOZY BOSQUET
79 AV. BOSQUET, 75007 PARIS

SUNFLOWER CAFÉ
41 AV. DE SUFFREN, 75007 PARIS

ZIA
22 AV. DE TOURVILLE, 75007 PARIS

les créations messagéres

WILLIAM
AMOR

WEBSITE

instagram: @william.amor

*VISITS BY APPOINTMENT
ONLY*

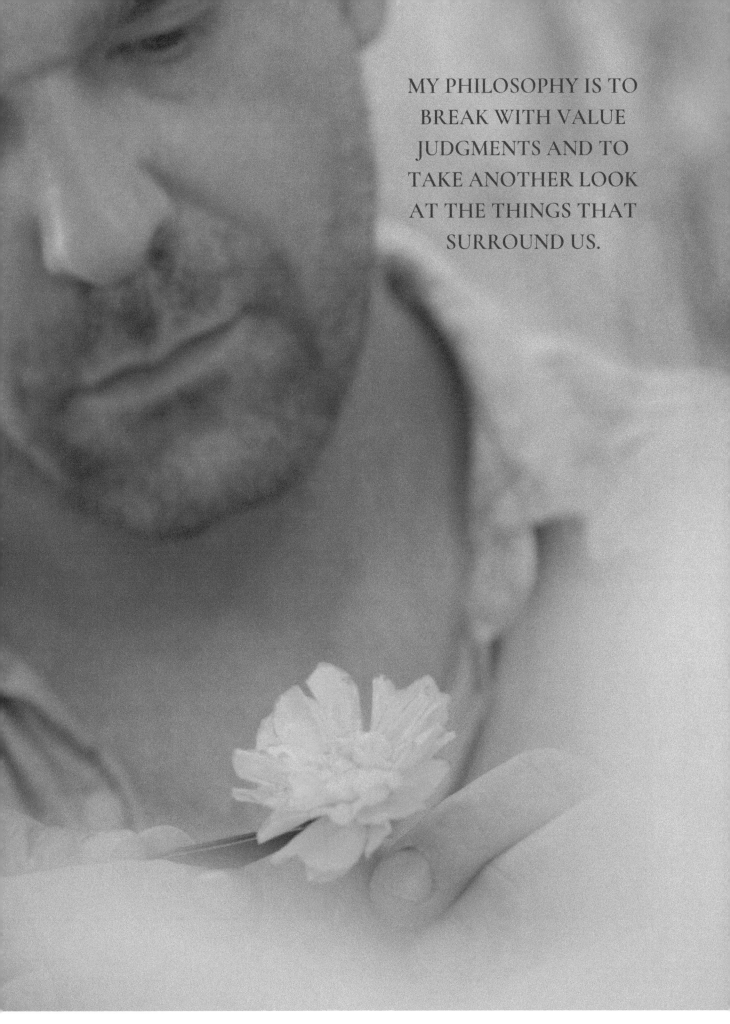

MY PHILOSOPHY IS TO
BREAK WITH VALUE
JUDGMENTS AND TO
TAKE ANOTHER LOOK
AT THE THINGS THAT
SURROUND US.

Artist
INTERVIEW

Q1

Please share your history and background with our readers.

My artistic approach of upcycling consumer products considered as waste to recover their material and ennoble them with nobility began around 2005.

I professionalized my approach and created my artist status and company in 2015.

Q2

How long does it take to make your artwork? How does your process work?

A very long time! Often hundreds or even thousands of hours for some projects with several months passing between the idea, the drawing, the selection or collection of the scraps, cleaning and preparation to final assembly.

Q3

As an artist, what does an average day look like for you?

Every hour is a surprise! There is no typical day. You have to adapt to the unexpected. I also discovered that by becoming a professional artist, I became an entrepreneur. That I have to juggle between imagining a project, selling it, transmitting and orchestrating a team, researching, experimenting, creating, producing but also communicating, & meeting clients. Boredom and procrastination are not part of my days!

My focus is to create
POETIC WORKS,
paying tribute to the
beauty of life
by ENNOBLING *our daily waste*
that has become unsightly
and harmful to our planet.

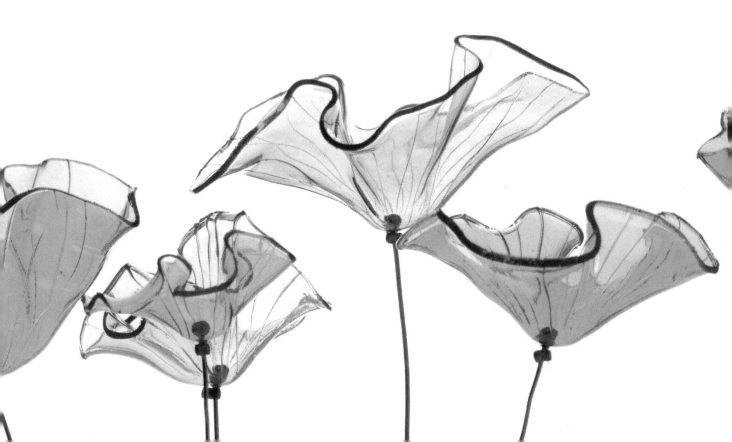

Artist
INTERVIEW

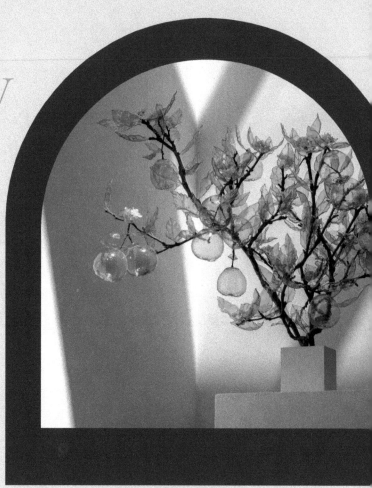

My artistic approach was born in Paris. I had the chance to grow up in the countryside in contact with nature and living things, and that's how my fascination for the world of plants and living things was born.

I was a child with a very sensitive character and a need to express myself artistically. The beauty and diversity of flowers has always interested and fascinated me. I dreamed of being a botanist, an artist, expressing my sensitivity. But at the time, I did not have access to the culture and belief that I could become an artist, that working from my passion could be possible.

A NEW BEGINNING IN PARIS

In Paris, the beginning of a young adult's life is not easy. I missed nature, plants and my landmarks.

So, I expressed myself artistically during my free time to make me feel good, painting, sculpture, lighting. It was an expression that I could relate to art therapy at the time.

INSPIRED BY URBAN SURROUNDINGS

During those first years in the city of light, I was a bit shocked to see the amount of waste soiling the capital.

And one day (when I missed flowers and the countryside), I focused my mind on a stray plastic bag, the texture of which reminded me of the fragility of flower petals.

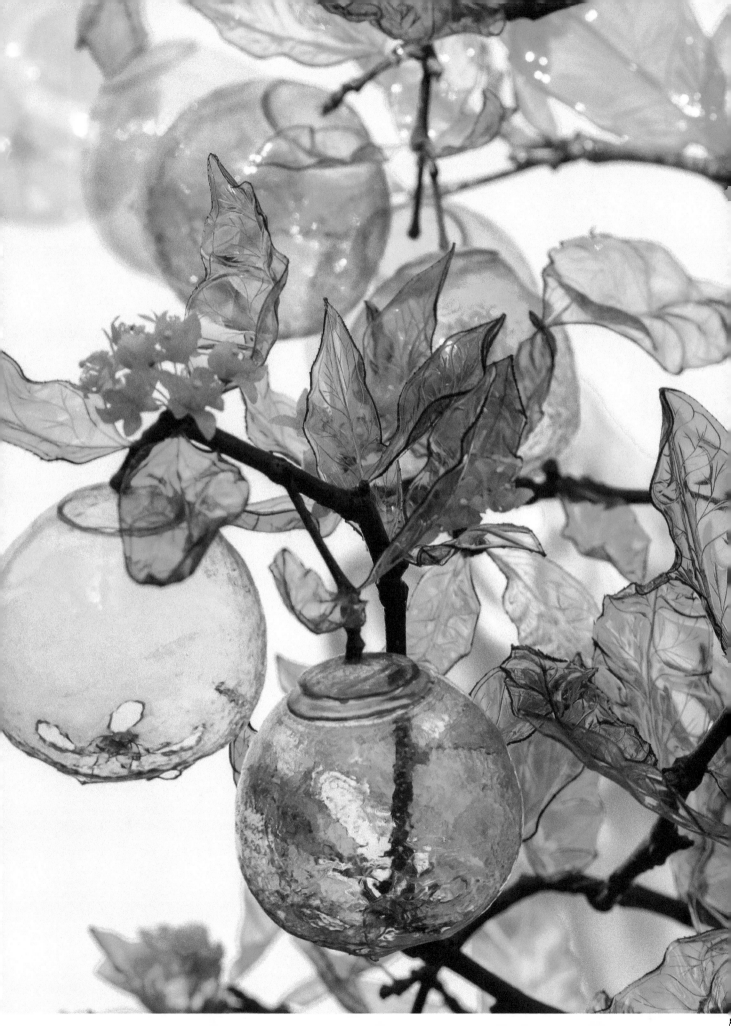

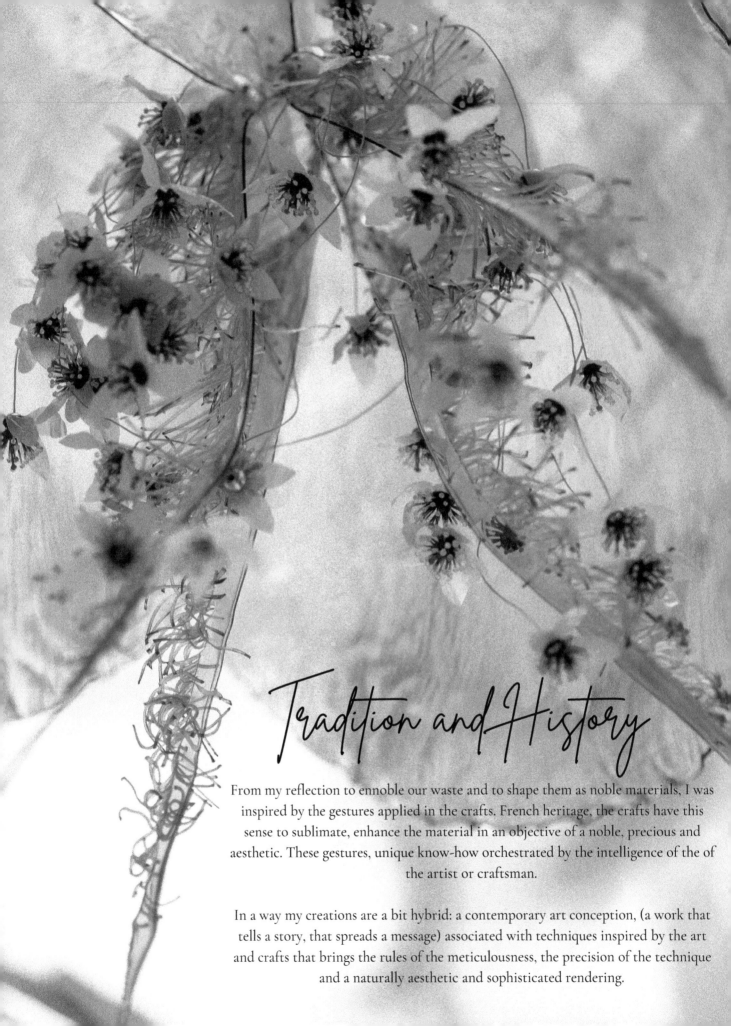

Tradition and History

From my reflection to ennoble our waste and to shape them as noble materials, I was inspired by the gestures applied in the crafts. French heritage, the crafts have this sense to sublimate, enhance the material in an objective of a noble, precious and aesthetic. These gestures, unique know-how orchestrated by the intelligence of the of the artist or craftsman.

In a way my creations are a bit hybrid: a contemporary art conception, (a work that tells a story, that spreads a message) associated with techniques inspired by the art and crafts that brings the rules of the meticulousness, the precision of the technique and a naturally aesthetic and sophisticated rendering.

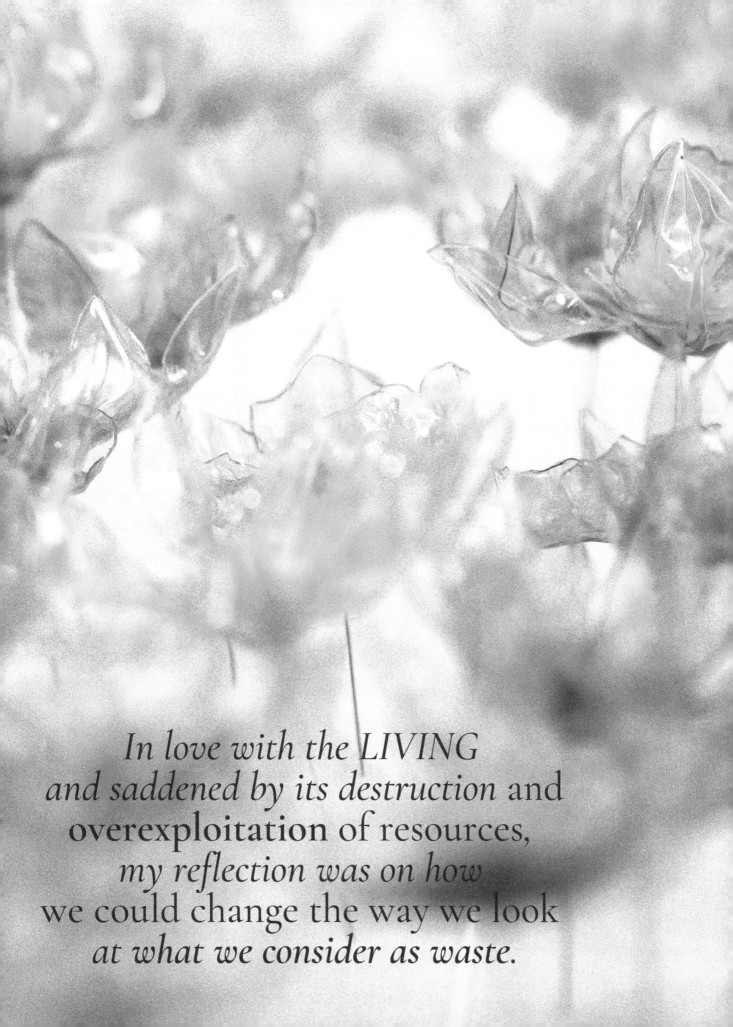

*In love with the LIVING
and saddened by its destruction and*
overexploitation of resources,
my reflection was on how
we could change the way we look
at what we consider as waste.

Artist INTERVIEW

I was asked if I was an environmental activist? My answer was no! My actions or my creations will not change the world. I just think to propose a little bit of sweet poetry to perhaps bring to carry another glance on the things, to break with the judgments of values.

This criticism could be reflected as follows: our value judgments can denigrate and discredit the true value of things, of the living, of humans and in the end can miss the essential, the true treasure... It's a bit like the revolution of our ugly waste that decides to reveal itself as noble as the diamond.

SOURCING MATERIALS

I consider our trash as messenger seeds. In this poetry, I try to recover materials in my daily life - when I cross garbage during my walks in the streets of Paris or washed up on the beaches during my vacations.

For certain projects, I call on the general public to participate in the depollution of an area and help me to collect the material. It is important for me, because it is the beginning of poetry.

AND CREATING ART

The objective is to create unique pieces of art, to order, that carry meaning and poetry. Creations that bring a little bit of fantasy and dream in this rather rough and violent world.

I let myself be carried by my intuition. Each project is a unique adventure that challenges everything. I want to constantly renew myself, to go further rather than be satisfied with what I have.

A

The objective: I only have one life, so I might as well fill it to the maximum, to share, transmit, learn to feel alive. And if I can leave some positive traces, I will be able in turn to metamorphose serenely.

TRAVEL IN FRANCE

N.6 2022

WINTER IN FRANCE

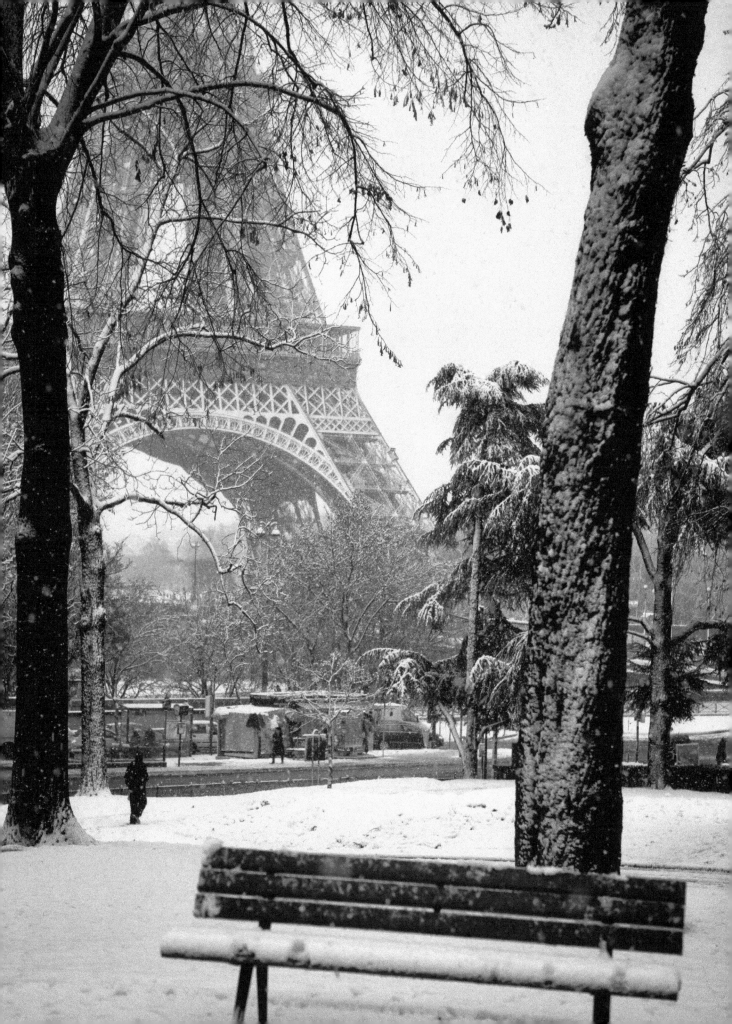

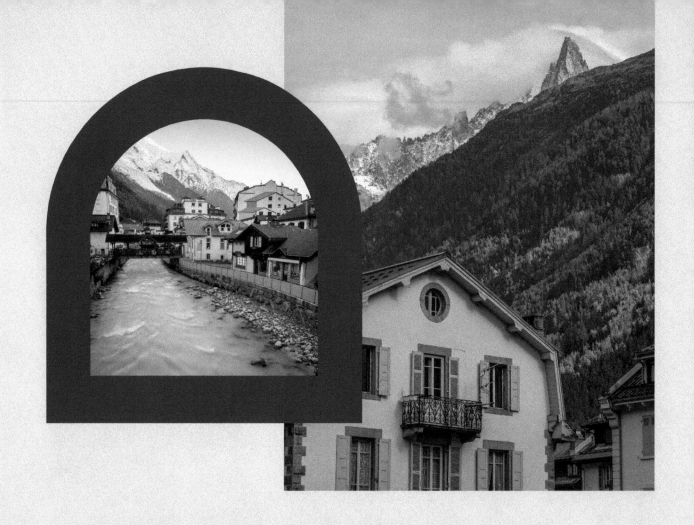

TOP WINTER
destinations

Let these winter
destinations in France
inspire you to explore
beyond Paris. Or perhaps in
your own backyard.

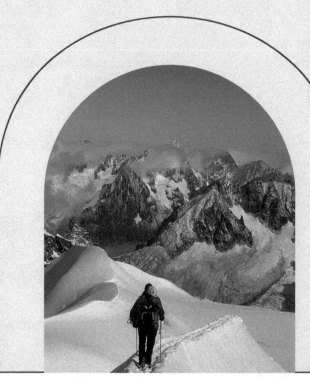

DO
This!

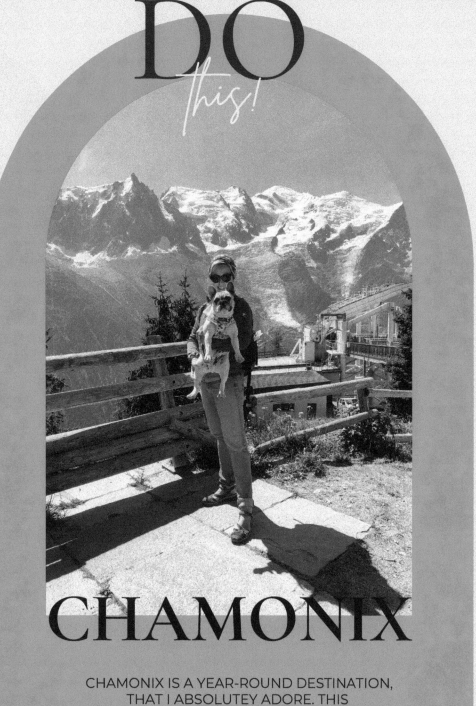

CHAMONIX

CHAMONIX IS A YEAR-ROUND DESTINATION,
THAT I ABSOLUTEY ADORE. THIS
INTERNATIONAL CITY COMES ALIVE WITH CONCERTS,
EVENTS, DISCOS, WINTER SPORTS EVENTS, AND
SO MUCH MORE. DO NOT MISS MER DE GLACE.

Lyon

Fête des Lumières

Light has always held a special place in the city and each year on 8 December, Lyon hosts the Festival of Lights. It is an international event renowned for the temporary light installations. The city is completely transformed into a stunning light show based on a wonderful tradition. Dating back to December 8, 1852, the residents of Lyon placed candles in coloured glasses on their window sills to celebrate the installation of a statue of the Virgin Mary on the Fourvière Hill.

fur

midi

explore this

THE FRENCH PYRENEES

Take the train from Paris to Lourdes,
where you can visit the famous
sanctuary and the fortified castle.
Consider hiking the Pic du Midi or the
thermal waters of Bagnères de Bigorre
or the Louron valley.

coastal
destination

SAINT-MALO, BRETAGNE

Bundle up for a seaside excursion to Saint-Malo, only about two hours via train from Paris.

Breathe in the fresh salt air and dive into trays of oysters after a long walk on the beach.

If you time it right, you might see one of the epic wave storms!

oui!

Champagne Region

REIMS AND EPERNAY

Trains to Reims only take 45-minutes. Aside from the stunning cathedral, this region offers much to explore, especially if you love BUBBLES! Visiting the champagne houses is a blast, by shuttle, car, or bicycle. What better way to celebrate that you are in France?

TOP TIPS WHEN RENTING A CAR IN FRANCE

These are my personal experiences and by no means comprehensive.

REVIEWS

VIDEOS

RECEIPTS

remember

1 Each car rental company acts as a franchise in France. Therefore, you'll want to thoroughly read the online reviews for each location. I have had success mostly with Hertz and EuropCar. But it will depend upon the individual office reviews.

2 Take videos of the car, inside and out, before you drive off. And when you return, do the same. Save the videos for up to six months as the rental agency can make a claim for many months after the rental.

3 Keep your gas receipts. Many agencies want proof of the fuel you used and paid for upon check out.

There is, between London and Paris, this difference that Paris is made for the foreigner and London for the English. England built London for its own use, France built Paris for the whole world.

Ralph Waldo Emerson

"

ROAM

STRASBOURG

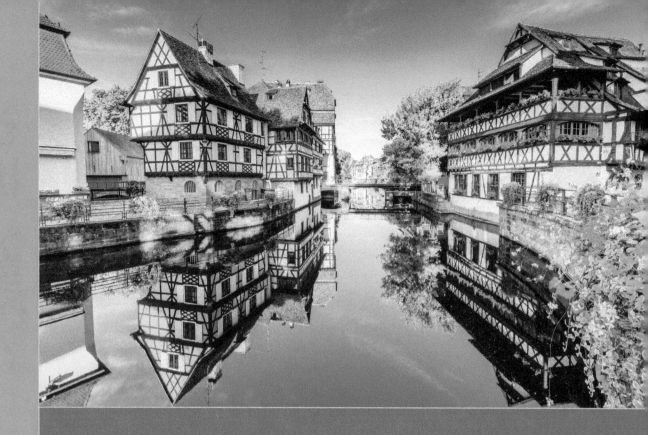

Rarely do we suffer our calculated risks - we always regret the ones we didn't take.

bonjour

It's December 2021, and my husband is returning to France. The poignant almost-regrets of Covid still lingered. While travel, even inter-country, remained a risk, I knew we had a unique opportunity to discover Strasbourg without the usual crowds. Rarely do we suffer our calculated risks - we always regret the ones we didn't take.

In these photos and videos, you'll see a lot of masks. Last December, Strasbourg retained and enforced its mask policy even when cities like Paris did not. It was a blatant reminder of the potential congestion of this experience.

CHRISTMAS IN ALSACE

sparkle

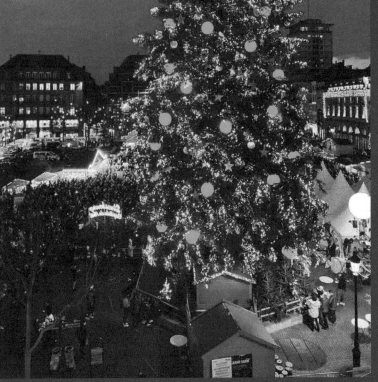

She sparkled and glimmered at night like a Strasbourg Eiffel tour, calling to visitors and locals alike to discover the marché noël, her cobblestone streets, and the spirit of Christmas around every corner.

The Largest Christmas Tree in Europe

This risk became our reward as Strasbourg and Colmar welcomed us with relatively empty arms. The apartment I chose was unique for this location and not for convenience - four flights of stairs later (the last flight being practically vertical), the view was worth every centime. Every night we opened the windows wide to fresh Alscasian air and a view of the largest Christmas tree in Europe.

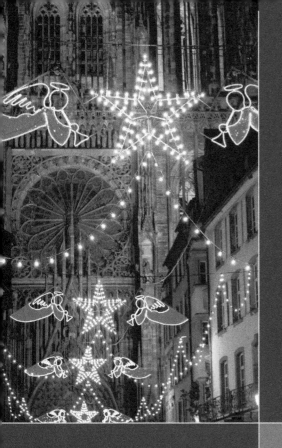

It is characteristic of long journeys to bring back something quite different from what one went there to seek.

Nicholas Bouvier

Estimated Travel Times

Train from Paris to Strasbourg - 1hour 45 minutes

Strasbourg train station to Place Kléber by foot - 15 minutes

Train from Strasbourg to Colmar - 20 minutes

Walk the entirety of Strasbourg old center quai - about an hour

It wasn't just Père Noël that I was in search of - I was looking for the beauty of living in France. Much like the ghosts of Christmas past, present, and future, my previous year in France was tinged with fear of a pandemic reaching our front door. We celebrated small, quietly together and were grateful for our health. But spending a holiday season hiding from a virus is no way to ring in the new year. Our trip to Strasbourg was about being present because we weren't sure what future ghosts would bring us.

The magic of Christmas came back to me childlike in Paris - soft, slow, with eyes wide and heart open. The gradual build, with a new window here, and a new installation there, was delivered without personal responsibility, gift wrap, or budget. I received the gift of a Parisian Christmas, arms wide open.

OLD AND NEW

Arriving in Strasbourg, it felt more commercialized, western, and fabricated. It was like the scene where Buddy the Elf decorates the department store. And yet, it was what I wanted and needed at the time. When my heart years for the glory of a childlike Christmas, I will return to Strasbourg and Colmar.

To find the new Strasbourg, Ascatians working and crafting in this area, go outside the touristic center. Strasbourg's accessibility to Paris makes this location uniquely strategic- especially for those in tech, as the town is near Geneva, Switzerland, Luxembourg, and Germany. Small and easily walkable, I encourage you to discover a youthful, vibrant, and creative city outside the immediate old town.

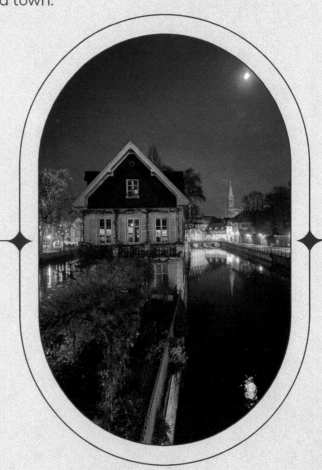

Explore outside of old town.

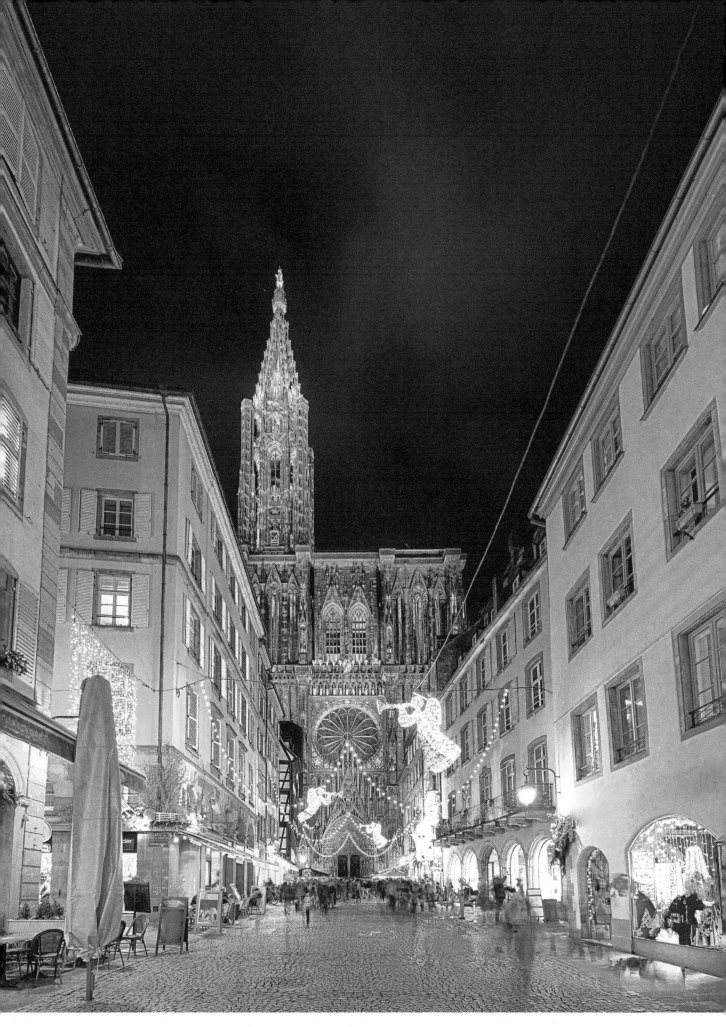

Vibrant & Modern

At one point, we found ourselves at a natural wine bar. The shop felt like equal parts Marais, a Grandmother's living room, and Alscatian comfort. The wines were spectacular examples of what a well-curated natural wine program could and should be. And on the other end of the spectrum, we visited the Stork Club, a modern art deco retro space. The space was a tremendous, open, and vibrant club, with great music, food in a constant stream from the kitchen, and a magnificent 360 bar. It was magical, transporting you to another space and time.

Colmar

A trip to Strasbourg is only complete if you visit Colmar. A thirty-minute train ride from Strasbourg, Colmar's historic and idyllic centre ville is a fifteen-minute walk from the train station. The approach was rather anti)climatic, but once inside old town, I was unprepared for the enormity of what Colmar offers.

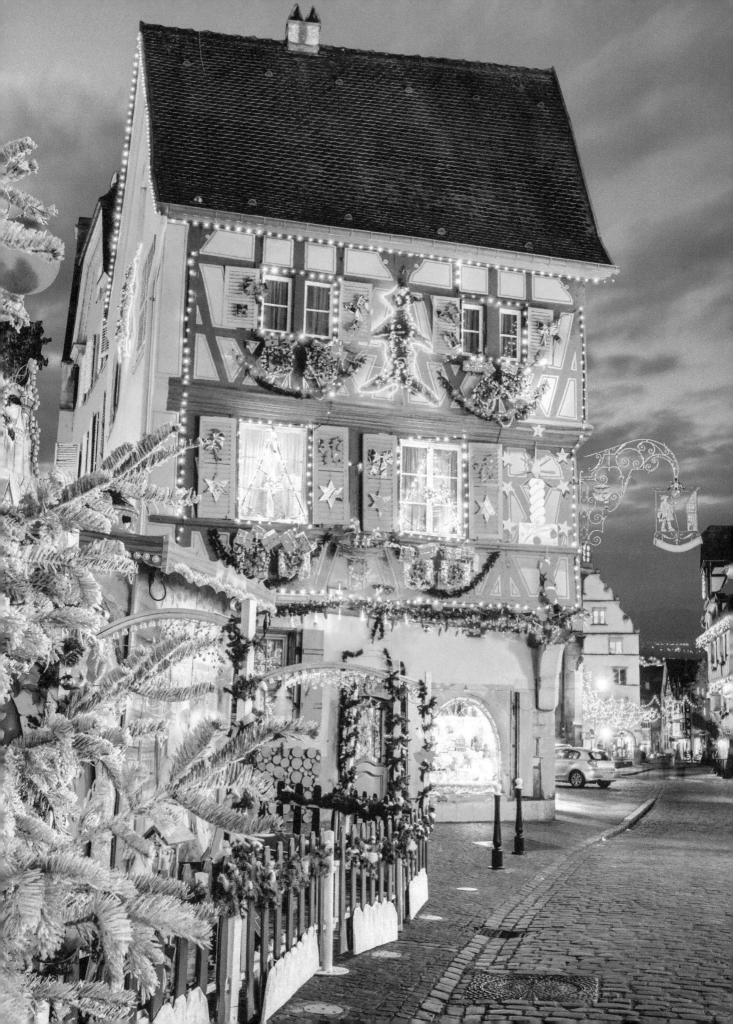

Must Visit
COLMAR, FRANCE

> *Colmar is an undulating, serpentine festival that winds its way non-stop, amongst half-timbered homes and cobblestone rues.*

Most marché noel in France are within a few block radius, at most. Strasbourg's markets are sprinkled throughout the old town in a few key locations. But Colmar is an undulating, serpentine festival that winds its way non-stop, amongst half-timbered homes and cobblestone rues. Transported to another era, each vendor offers a different product, craft, or food item for sale. We never saw it all; as the sun started to set, so did the temperatures and our will to remain outside.

JaJa Wine Bar
04 Pl. Saint-Nicolas aux Ondes, 67000 Strasbourg

Pack for Winter

The cold was gripping the day we visited. I wore thermals under layers, and I still was chilled to the bone each evening, choosing a hot shower and my bed comforter over going back out late at night.

If you are visiting during the winter, I highly suggest that you pack as if you are going to the snow - heavy boots, socks, gloves, scarves that can cover your face, hat, and lots of thermals.

Strasbourg
CHRISTKINDELSMÄRIK

The Christkindelsmärik, or "market of the child Jesus," is the name given in the Alsatian language to the Strasbourg Christmas market, which has been held since 1570.

Place Broglie

Today, the Christkindelsmärik still stands on the vast Place Broglie (former Horse Market), considered its historic site, to which other places in the city have been added.

In the 1900s , the eastern part of Place Broglie, from the Municipal Theater to the current rue de la Comédie, was reserved for tree merchants, while the western part, to the current rue du Dôme, had stalls offering sweets, toys and decorations for the Christmas tree.

Christmas markets of today

Eleven Christmas markets are featured in Strasbourg now and are located at Places de la Gare, Kléber, du Temple-Neuf, de la Cathédrale, d'Austerlitz, Corbeau, Benjamin-Zix, des Meuniers.

·Strasbourg was named "Best Christmas Market" twice by European Best Destinations and named the "World's Best Christmas Market" by CNN Travel in 2018. The town now receives over two million visitors each holiday season.

The best way to avoid crowds is to come on weekdays in the first half of December.

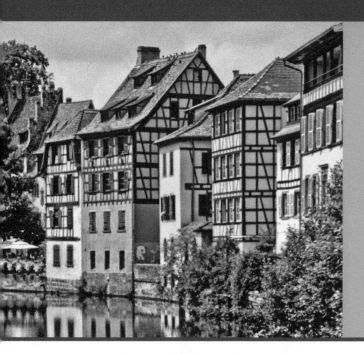

Did you know?

About 20 million travellers use the Strasbourg train station every year. The town has the biggest tram system in France, with 71.8 km.

DID YOU KNOW?

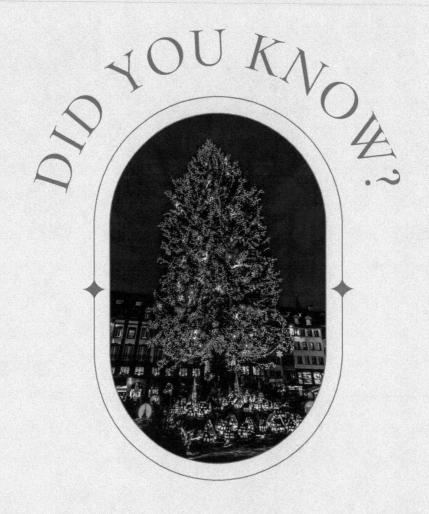

This 30-metre-high tree, carefully selected in the Vosges Mountains, is the greatest symbol of Strasbourg, Capital of Christmas. The decorations chosen this year revisit French ancestral traditions – with a modern twist.

Strasbourg Statistics

7th
LARGEST CITY IN FRANCE (POPULATION)

670
KM OF BIKE PATHS

2nd
LARGEST RIVER PORT IN FRANCE

3rd
GREENEST CITY IN FRANCE

Secret!

In the district of Petite France, the most beautiful view is at the "Barrage Vauban."

Access to the building is free.

Head up to the first floor and try to catch the reflection of the river, the half-timbered houses, and covered bridges.

And the cathedral will be in the background too!

Another beautiful spot?

Place des Tripiers

CUISINE

Recommended Strasbourg Restaurants

Muensterstuewel
FINE DINING

8 PL. DU MARCHÉ-AUX-COCHONS-DE-LAIT, 67000 STRASBOURG

La Cloche à Fromage
CHEESE SHOP, RACLETTE

27 RUE DES TONNELIERS, 67000 STRASBOURG

Chez l'Oncle Freddy
ALSATIAN

9 RUE DES MOULINS, 67000 STRASBOURG

Brasserie Des Haras
18-TH CENTURY FARM

23 RUE DES GLACIÈRES, 67000 STRASBOURG

Café Bretelles Petite France
COFFEE & HOUSEMADE CAKES

36 RUE DU BAIN-AUX-PLANTES, 67000 STRASBOURG

The Drunky Stork Social Club

24 RUE DU VIEUX-MARCHÉ-AUX-VINS, 67000 STRASBOURG

EAT

Strasbourg
FAVORITES

PATISSERIE CHRISTIAN STRASBOURG

12 Rue de l'Outre, 67000 Strasbourg

TRADITIONAL TEA HOUSE NEAR THE CATHEDRAL. WE GOT BREAKFAST PASTRIES HERE EVERYDAY!

THEIRRY MULHAUPT

5 Rue du Temple Neuf, 67000 Strasbourg

BEST KOUGELHOPF IN STRASBOURG. BEAUTIFUL PASTRIES AND A LOVELY LIME BASIL TART.

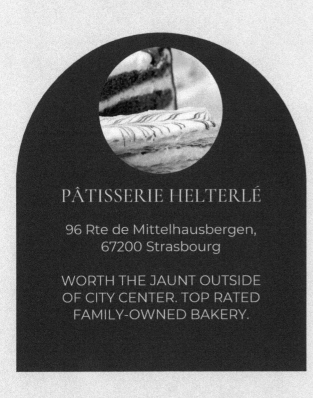

PÂTISSERIE HELTERLÉ

96 Rte de Mittelhausbergen, 67200 Strasbourg

WORTH THE JAUNT OUTSIDE OF CITY CENTER. TOP RATED FAMILY-OWNED BAKERY.

AU PAIN DE MON GRAND-PÈRE

1 Rue des Hallebardes, 67000 Strasbourg

TRY THE BRETZEL WITH EMMENTAL CHEESE.

A LIST COLLABORATION WITH @MOLLYJWILK

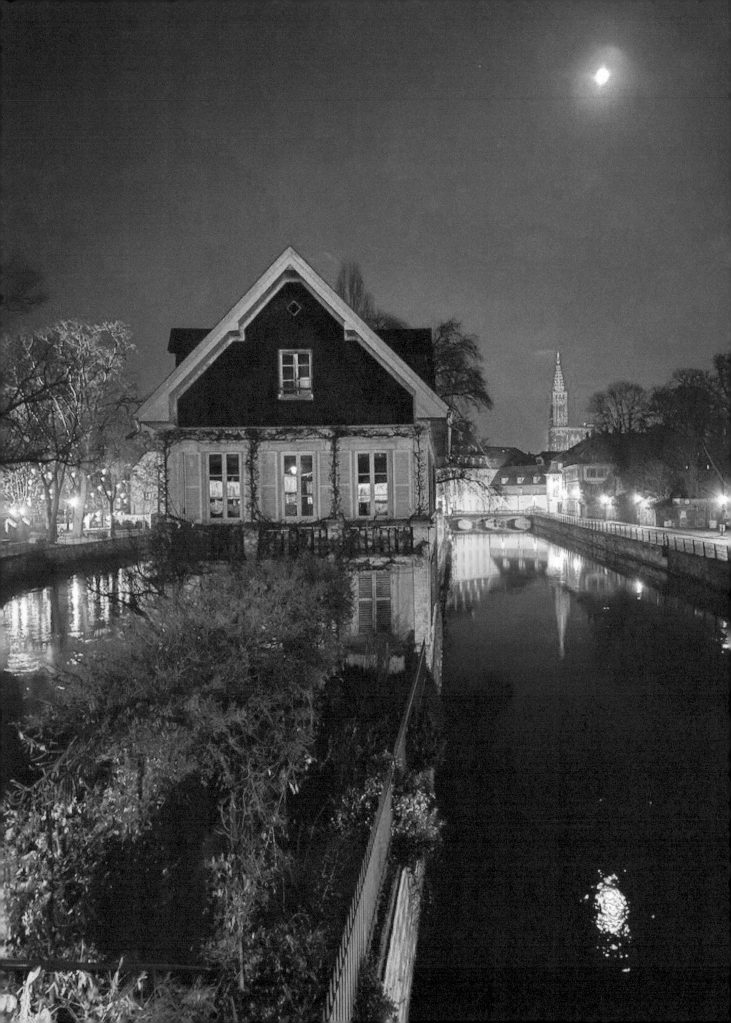

COLMAR
DAY TRIP

30 min train

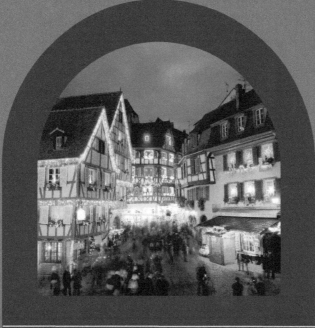

WHEN: Leave after breakfast

ARRIVE: Mid-morning

DURATION: Three to four hours

When I travel by train in France, I use the application (web or phone) called Trainline. I pre-booked our train tickets and knew how long it would take to walk from the apartment to the Strasbourg train station, allowing extra time to find the correct platform.

It's a short, commuter train ride to Colmar and the walk into town takes about 15-minutes. I suggest booking restaurant reservations in advance. A few places to try are Version Originale 68, Les Six Montagnes, or Wistub de la Petite Venise. Don't forget to use Trainline to book your return trip too!

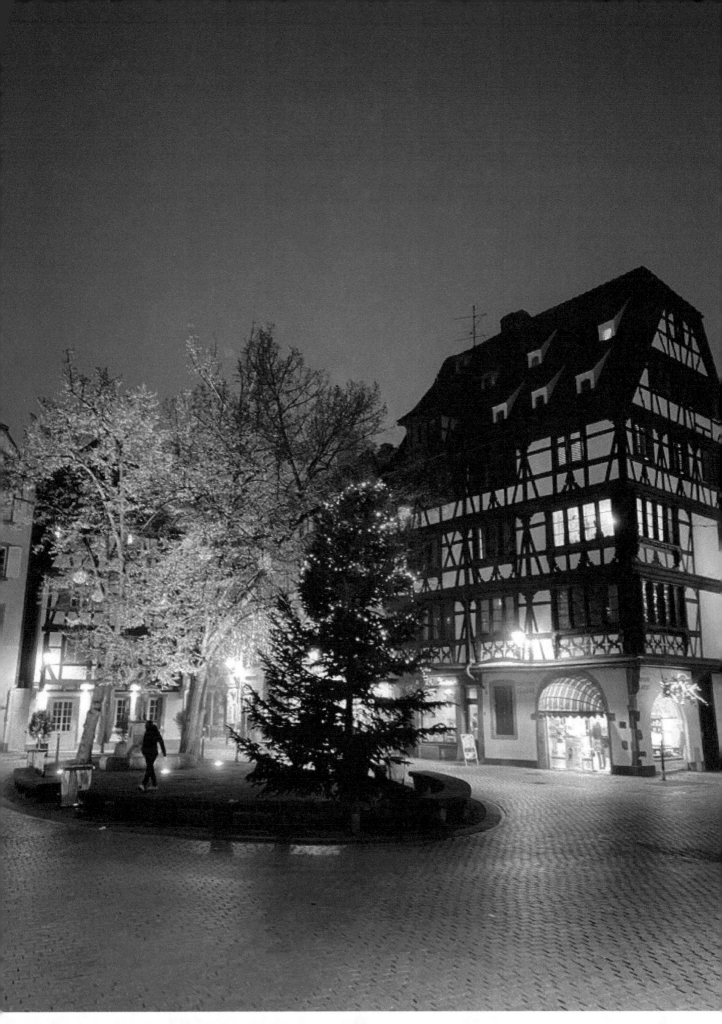

REGIONAL VILLAGES

Want to rent a car? Here are other villages you cannot miss while in Alsace. These are all relatively close to Strasbourg. TIP: Allocate time for inclement weather!

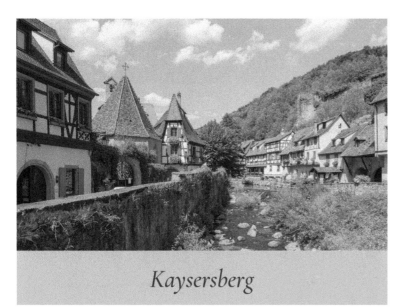

Kaysersberg

Riquewihr

YEAR-ROUND, THESE VILLAGES ARE WORTH A VISIT.
DURING THE SUMMER MONTHS, ENJOY HIKING, EXPLORING LOCAL LAKES,
AND LOVELY WARM TEMPERATURES. DURING THE WINTER,
EACH ONE OF THESE VILLAGES HAS A SPECTACULAR MARCHÉ NOEL.

Ribeauvillé

Eguisheim

Obernai

Wissembourg

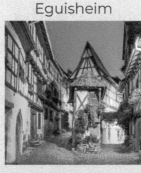

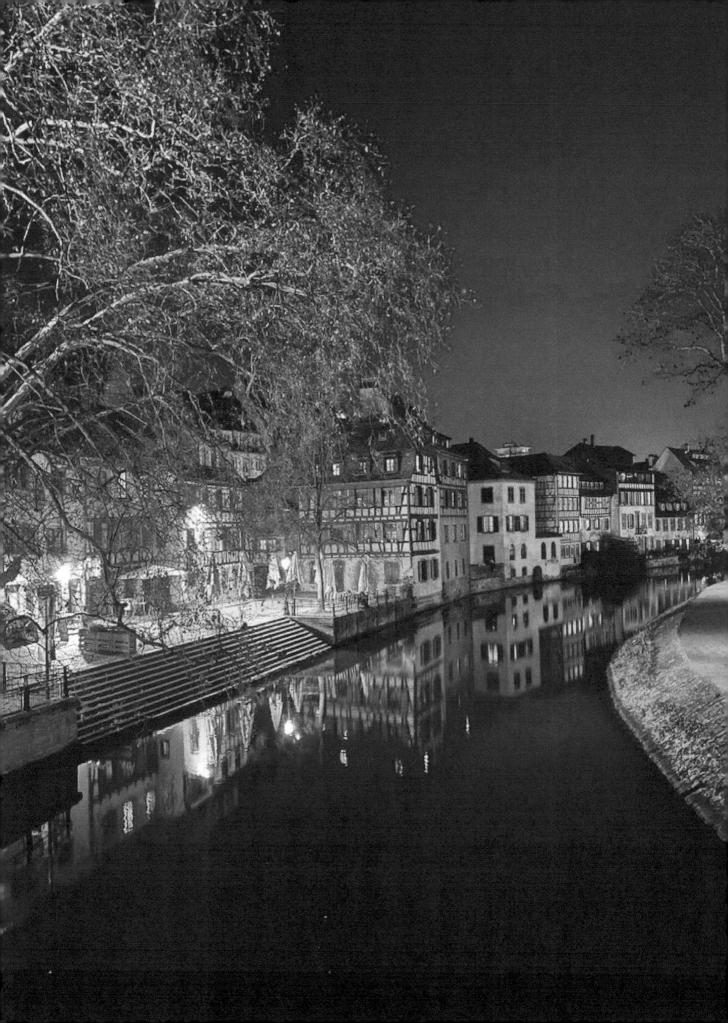

UN HOMME VOYAGE
POUR SENTIR ET POUR
VIVRE. A MESURE QU'IL
VOIT DU PAYS, C'EST LUI-
MÊME QUI VAUT MIEUX
LA PEINE D'ÊTRE VU.

A MAN TRAVELS TO FEEL AND TO LIVE. AS HE SEES THE
COUNTRY, HE HIMSELF IS MORE WORTH SEEING.

ANDRE SUARES

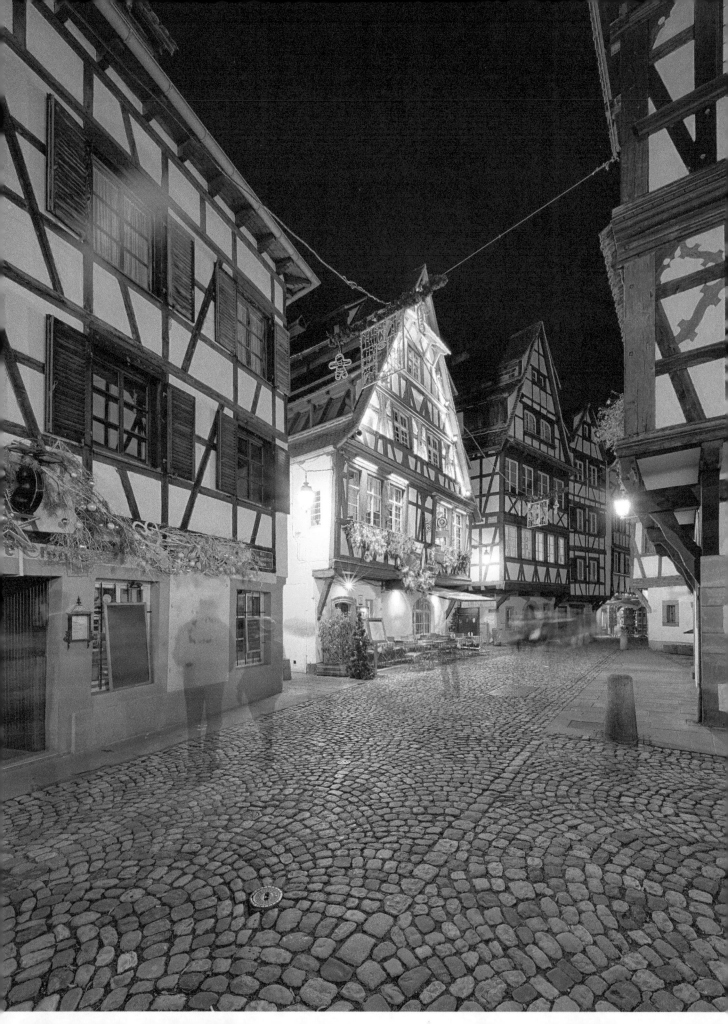

ADDITIONAL TIPS & SUGGESTIONS

A two-night, three day trip is a nice paced visit for Strasbourg and Colmar.

The first day, travel from Paris after breakfast and arrive around lunch time in Strasbourg. Check into the hotel, stroll the town during the day, and see the sights at night.

The second day you can commit entirely to Colmar with a final evening stroll through Strasbourg.

And on the third day, hit up some some of those Alsatian bakeries for the train ride home to Paris!

Bon Voyage!

EXCLUSIVE RESOURCES & *TOOLS*

DAY ONE

Our departure from Paris, arriving into the Strasbourg train station, & exploring Strasbourg.

WATCH NOW!

DAY TWO

In part two of three, I share our day trip to Colmar, plus the arrival and departure from the train station.

WATCH NOW!

Day Three

If you missed it, my third day included a visit to the fabulous Cloche à Fromage restaurant. I also visited an antiques flea sale in this video, so don't miss it!

WATCH NOW!

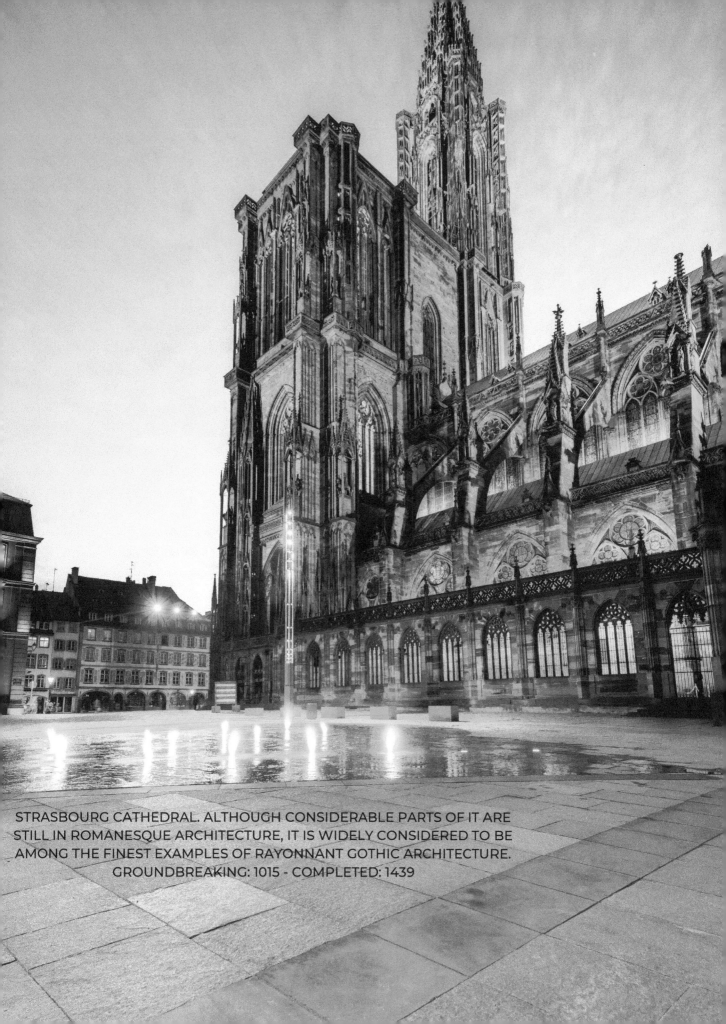

STRASBOURG CATHEDRAL. ALTHOUGH CONSIDERABLE PARTS OF IT ARE STILL IN ROMANESQUE ARCHITECTURE, IT IS WIDELY CONSIDERED TO BE AMONG THE FINEST EXAMPLES OF RAYONNANT GOTHIC ARCHITECTURE. GROUNDBREAKING: 1015 - COMPLETED: 1439

CALENDAR & EVENTS

N.6

2022

PLANNING & RESOURCES

Paris
EVENTS THIS WINTER

Petite Palais

Andre Devambez. Dizziness of the Imagination. The Paris of the Belle Epoque painted, engraved and illustrated. 250 works tinged with humor featuring the capital, with plunging views and original framing.

Until Dec 31

Musee Picasso

Discover the source of inspiration that the master's daughter represents for his art, through a series of portraits of the child painted by his Picasso , as well as sculptures, photos and archives.

Until Dec 31

Louis Vuitton

Monet-Mitchell. Dialogue and retrospective. Impressionist Claude Monet and the American Joan Mitchell, leading artist of the abstract expressionist movement. Landscapes that echo each other.

Until Feb 27

ACCESS THE EVENTS

CLICK ON ANY OF THE IMAGES TO OPEN UP THE EVENT SITE.

Paris will always be Paris. What else do you want him to do?

Frédéric Dard

Quai
Branley

Kimono.
1000 years in the history of traditional Japanese focused on clothing and its influence on modern styling and design.

Architecture &
Heritage

Exploration of the dialogue of artistic influence between France and North America for the Art Deco style and the inspiration that results.

Orangerie
Museum

Sam Szafran – Obsessions of a painter. Self-taught artist drawing his creations from poetry and his inner strength.

Until May 28

Until March 6

Until Jan 16

ACCESS THE EVENTS

CLICK ON ANY OF THE IMAGES TO OPEN UP THE EVENT SITE.

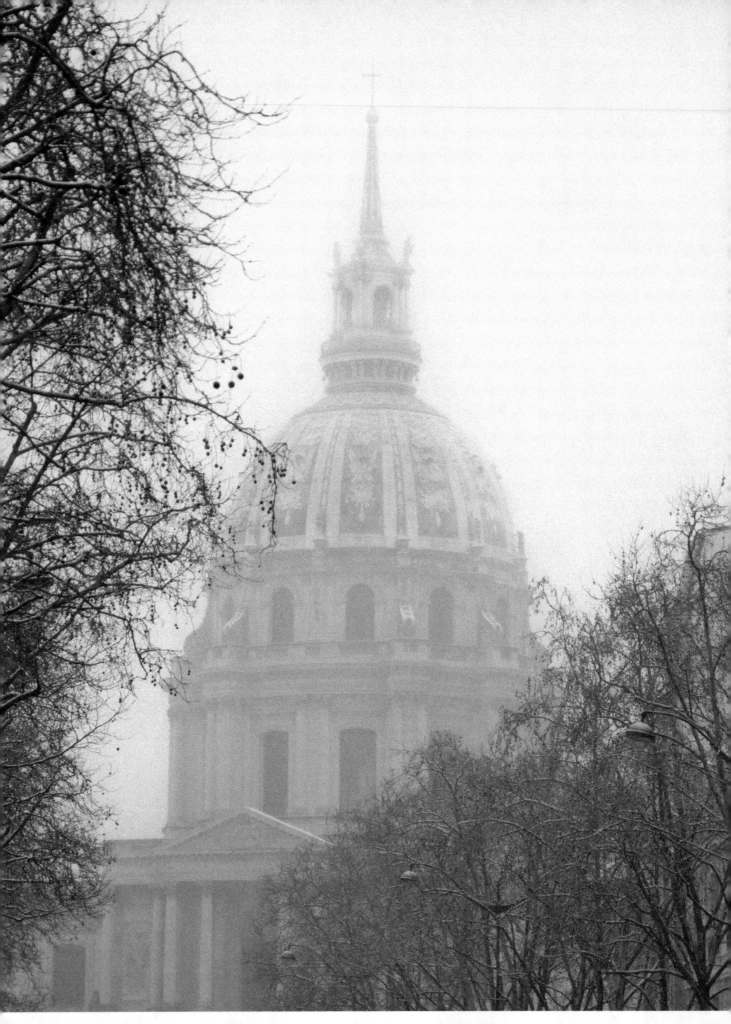

"Also in Paris, if you really pay attention, you can feel at every step the pulsation of a big heart under your sole."

Henri Calet

Yves Saint Laurent

Gold Yves saint Laurent. Through jewels or sequins, the golden hue is the signature of the great couturier Yves Saint Laurent . A colorful journey through some forty haute couture and ready-to-wear dresses.

Until May 14

Mogador Theater

Simba, Scar, Nala, Timon and Pumba return to the delight of young and old alike in a playful and colorful show, which promises to be one of the events not to be missed in Paris.

Until Dec 31

Musée Armée

This autumn, the Musée de l'Armée is presenting the first ever exhibition devoted to the French Special Forces, which will lift the veil on one of their armies' most secretive entities.

Until Jan 29

STAY TUNED!

I will be posting the latest events and happenings, on my Instagram channel here.

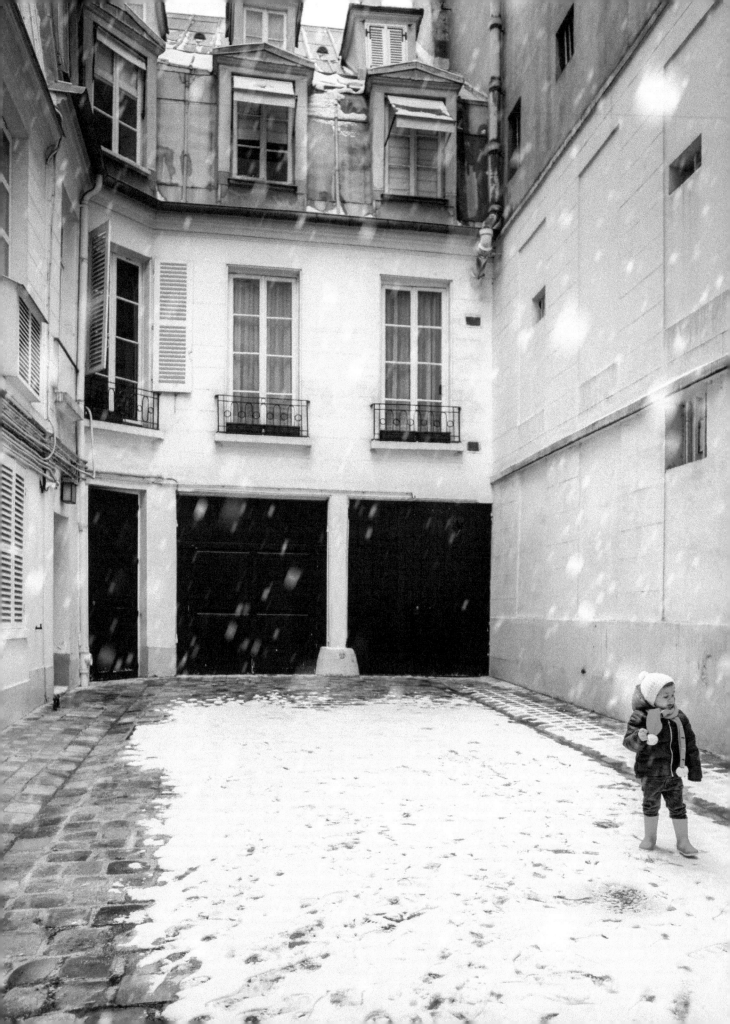

VIDE GRENIERS

A vide grenier is a flea, boot, or collective garage sale, generally held outdoors. Most vides for January have not been released at the time of this publication.

Dec
4

RUE DES FOSSÉS ST BERNARD & PL JUSSIEU

120 EXHIBITORS

Dec
7

BROCANTE PRO BLVD HAUSMANN 9TH

120 EXHIBITORS

Dec
10

BROCANTE PRO BLVD DU MONTPARNASSE

120 EXHIBITORS

Dec
10

GEORGES HÉBERT SPORTS CENTER

250 EXHIBITORS

Dec
11

RUE DE BELLEVILLE, RUE DU TÉLÉGRAPHE 20

250 EXHIBITORS

Dec
17

BROCANTE PRO RUE CAULAINCOURT

120 EXHIBITORS

PLEASE NOTE THAT THE NUMBER OF EXHIBITORS IS THE MAXIMUM BUT MAY BE LESS DAY OF.

IT WAS LATE ; LIKE A NEW MEDAL, THE FULL MOON SPREAD OUT, AND THE SOLEMNITY OF THE NIGHT, LIKE A RIVER OVER SLEEPING PARIS, FLOWED.

CHARLES BAUDELAIRE

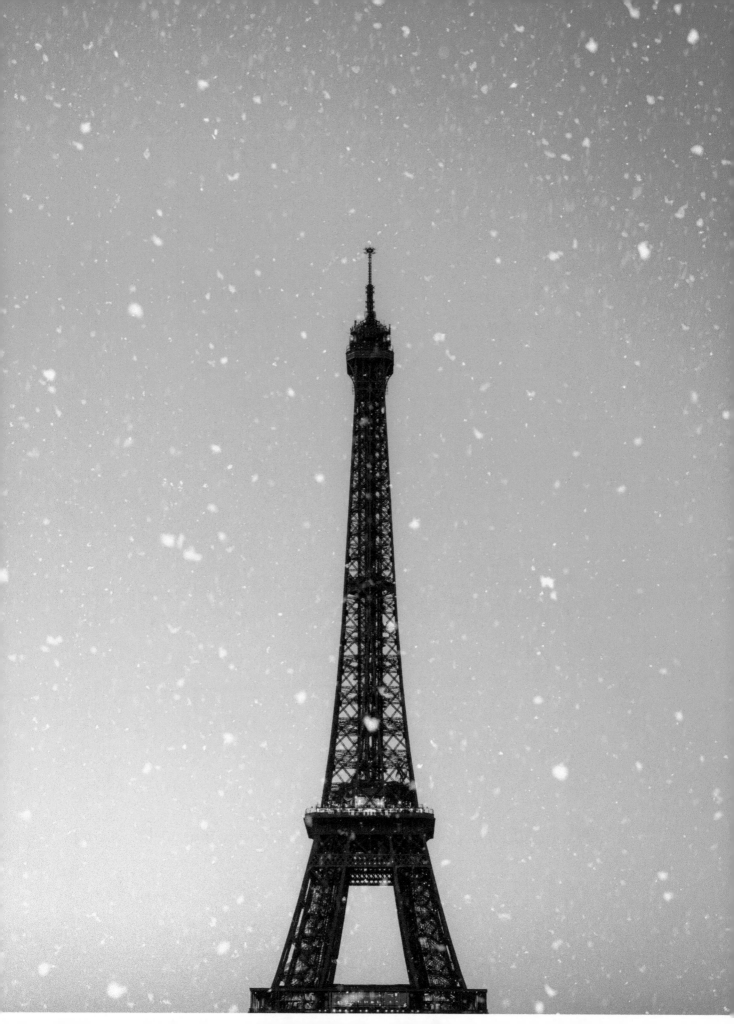

PRACTICE GRATITUDE

As we end the year and look forward to a new start, let's reflect on the moments, big and small, that we are grateful for.

What am I grateful for?

What moments made me happiest this year?

As a Francophile, how can I incorporate more of France into my life in 2023?

Three Goals to Start the Year

1

MY GOAL

ACTION STEPS

01 _____
02 _____
03 _____
04 _____
05 _____

MY IMPRESSIONS

2

MY GOAL

ACTION STEPS

01 _____
02 _____
03 _____
04 _____
05 _____

MY IMPRESSIONS

3

MY GOAL

ACTION STEPS

01 _____
02 _____
03 _____
04 _____
05 _____

MY IMPRESSIONS

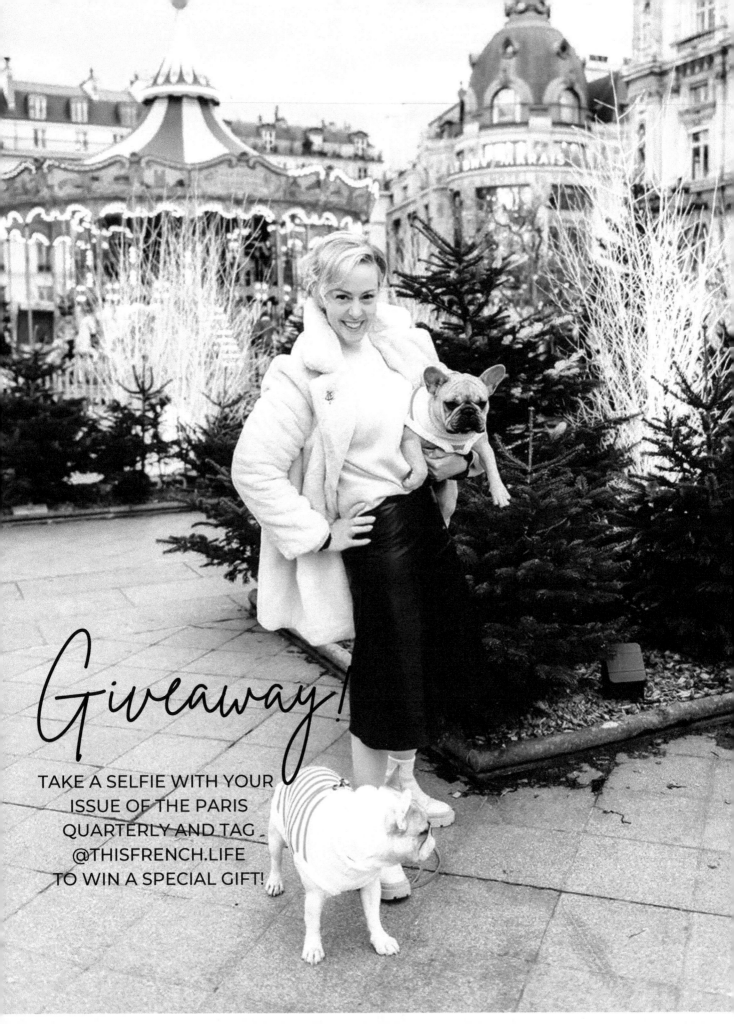

Giveaway!

TAKE A SELFIE WITH YOUR
ISSUE OF THE PARIS
QUARTERLY AND TAG
@THISFRENCH.LIFE
TO WIN A SPECIAL GIFT!

FRANCE TRAVEL PLANNER
INSTANT DOWNLOAD

For you, my fellow Francophile, I have created FIFTY pages of tips, tricks, templates, and information you need for your next trip to France. The Ultimate France Travel Planner has ARRIVED!

I WANT TO LEARN MORE!

99

I never thought I'd have the chance to see Paris. And now I can't possibly imagine leaving.

GET YOUR
CUSTOM ITINERARY!

Are you planning a trip to France? But maybe you are feeling
a little overwhelmed or concerned?

No problem! I have partners, resources, and tools to help you with that.

SEND ME A MESSAGE NOW!